M000226299

Merry Christmas

Mom + Dad

2001

# The State Botanical Garden of Georgia

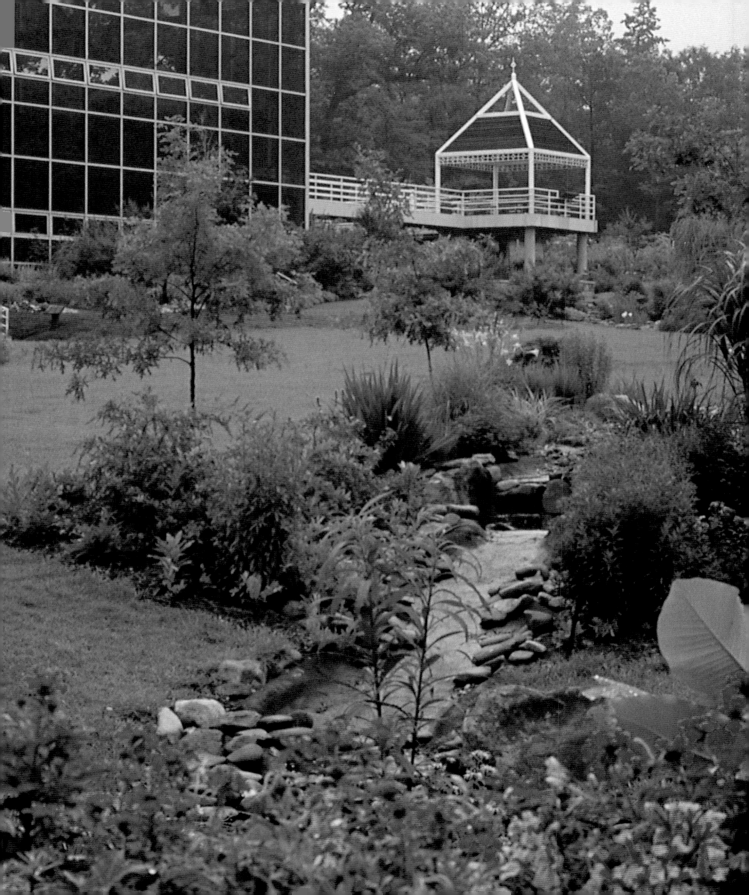

# The State

Carol Nourse & Hugh Nourse

# Botanical Garden

The University of Georgia Press    Athens & London

# of Georgia

© 2001 by the University of Georgia Press
Athens, Georgia 30602
All rights reserved
Calligraphy by Ken Williams
Book design by Sandra Strother Hudson
Printed and bound by C & C Offset Printing Company
The paper in this book meets the guidelines for permanence
and durability of the Committee on Production Guidelines
for Book Longevity of the Council on Library Resources.

Printed in Hong Kong

05  04  03  02  01  C  5  4  3  2  1

Library of Congress Cataloging-in-Publication Data
Nourse, Carol, 1933–
The State Botanical Garden of Georgia / Carol Nourse and
Hugh Nourse.
       p. cm.
ISBN 0-8203-2327-6 (alk. paper)
1. State Botanical Garden of Georgia. 2. State Botanical Garden
of Georgia—Pictorial works. I. Nourse, Hugh O.  II. Title.
QK73.U62  G466  2001
580'.7'375818—dc21          2001027289

British Library Cataloging-in-Publication Data available

*Frontispiece:* The International Garden and the
Visitor Center pavilion

# CONTENTS

# ACKNOWLEDGMENTS

THANKS to the Friends of the State Botanical Garden of Georgia, who have provided support for the publication of this book.

We are indebted to the director, Dr. Jeff Lewis, and the entire staff of the State Botanical Garden of Georgia for the unending work they do to create and maintain this beautiful garden. There could be no beautiful photographs of the Garden without their creativity. We also appreciate the staff's cheerful and helpful sharing of information. In particular, Jeff Lewis and Shirley Berry assisted in the preparation of the list of flowering times.

We must especially acknowledge the support and enthusiasm of Misty Herrin, who was the public relations coordinator for the first several years we were photography volunteers for the Garden. From the day we first walked into her office offering to provide slides of the Garden for staff use, Misty's encouragement and enthusiasm kept us coming back with more and better photos. Brody Boyer, the current graphics artist at the Garden, continues to provide that encouragement and enthusiasm.

We acknowledge the teaching of Les Saucier, who showed us how to evaluate and improve our photography. The members of the Athens Photography Sharegroup continue to inspire us.

Barbara Ras, our editor at University of Georgia Press, has been encouraging and helpful as this project has developed.

Thanks to all!

# FOREWORD

HUGH AND CAROL NOURSE see the State Botanical Garden of Georgia in multifaceted ways that often escape the average visitor. From close-ups to panoramic landscapes, their photographs freeze a scene in a way that allows us to truly appreciate the Garden and often to notice details we might otherwise miss—symmetry, texture, form, color—of nature in all its richness.

Their work is an exercise in patience and skill—the art and science of photography. Always perfectionists, they understand the importance of lighting, exposure, and composition in creating a beautiful and technically correct photograph. Getting "the" photograph is rarely accidental but rather almost always the result of careful planning and attention to detail and comes often at the cost of getting up early and lugging heavy but breakable cameras, lenses, and other photographic equipment.

The images selected for this book convey the seasonality of a temperate garden in both the man-made and natural landscapes contained within the Garden's 313 acres—wetlands, floodplains, slopes, and upland plateaus typical of Piedmont Georgia. This book is organized around seasonal change, through which the Garden derives much of its ever changing beauty and intrigue. The State Botanical Garden is very much a four-season garden with generally mild winters, glorious springs, sweltering summers, and dazzling autumns. In the Garden, nature marches on, flowers bloom and fade, and life cycles repeat themselves, even in the dead of winter.

These beautiful images capture the physical dimension of the Garden, and at the same time they suggest its deeper meaning and broader purpose—a place that brings people, programs, and events together in context with nature for educational, social, recreational, and even spiritual purposes. But image, appearance, and appeal are important in their own right, for people must first learn to see and appreciate, understand and value, before they can be moved toward the conservation and stewardship actions promoted by the Garden.

The natural world around us is increasingly under siege as green spaces shrink, habitats disappear, and large, biodiverse regions of the planet are denuded or degraded. Through their photography, the Nourses champion conservation and environmental education and help us realize both the beauty and the fragility of plants in our own surroundings.

Hugh and Carol Nourse have been very generous over the years in allowing the Garden to use their photographs in presentations and publications and on our web site. The beautiful images in this book offer an exciting vista into this special place we call the State Botanical Garden of Georgia.

JEFF LEWIS
Director
The State Botanical Garden of Georgia

# INTRODUCTION

EARLY SPRING WILDFLOWERS on a nature trail, a mass of blooming azaleas, dogwoods, and wisteria in April, a riot of colorful annuals in July, a crimson canopy of Japanese maples in October: the State Botanical Garden of Georgia provides a visual feast at any time of year.

Located on more than three hundred acres of varied piedmont terrain, the Garden provides opportunities for recreation, research, and education with its combination of natural areas, landscaped display gardens, and buildings. It is a relatively new garden, first proposed in 1967, but it has rapidly become one of the premier gardens of the Southeastern United States. Originally known as the University of Georgia Botanical Garden, it always has had a mission to serve educational and research purposes as well as to collect and display plants.

The idea for a botanical garden to serve as a "living plant library" was first proposed by Dr. Francis E. Johnstone Jr., a professor of horticulture at the University of Georgia. In 1968, the president of the university, Dr. Fred Davidson, approved development of plans for a botanical garden to "serve the teaching, research and service areas" of the university. After the University and Board of Regents approved the proposal, a faculty committee quickly selected a site and proposed a budget and financial plan.

The site chosen lies in Clarke County, about two miles south of the university's main campus. It has more than a mile of frontage on the Middle

Oconee River and also includes two spring-fed streams. Within the boundaries exist four principal habitats of the Georgia piedmont: floodplain, slopes, up-

land plateaus, and wetlands. This last habitat was gained by the 1990 acquisition of twenty acres on the opposite side of the river in Oconee County. In addition, beaver activity has created some quasi-wetlands on the Clarke County side.

*Japanese maple in front of the Callaway Building*

The site also represents successional stages ranging from stands of mature trees to fields last tilled in the 1960s. Both the preliminary plan and a master plan adopted in 1990 specify that a major portion of the site will remain as maturing forest, to protect the Middle Oconee River and to serve as a buffer between the developed gardens and surrounding land uses.

The first facilities for public use were three miles of trails laid out and cleared by the university's Physical Plant Grounds Department, with the help of volunteers. Even in the first year the trail system was used by more than fifteen hundred students for field trips and research projects. The following year, Governor and Mrs. Jimmy Carter walked the trails accompanied by members of the Garden Club of Georgia, the Botanical Garden Faculty Committee, and others. The governor allocated $13,000 for the development of a master plan for the Garden. Early support came from the Georgia Horticultural Society, the Garden Club of Georgia, and many other groups. The Friends of the State Botanical Garden, chartered in 1972, now sponsors a number of annual events and fund-raising activities.

The Callaway Foundation provided funding for the first permanent building. Completed in 1975, the Callaway Building serves as administrative headquarters, with research, teaching, and office spaces on the lower level and

auditorium, reception, and conference rooms and a small library on the upper level.

Today the Garden contains four major buildings and a variety of display gardens and plant collections. The Visitor Center, which serves as focal point, was also made possible by a gift from the Callaway Foundation. The striking glass and steel structure features a two-level conservatory containing tropical and semitropical plants, particularly those of economic importance.

Adjacent to the Visitor Center, the International Garden is the most recent major garden. This complex landscape explores the historical and evolving relationships between plants and people. The planting areas are grouped around a large central lawn, which is bisected by a man-made rocky stream flowing from a slab of polished black

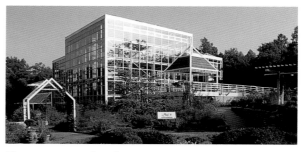

*The conservatory and pavilion*

rock mounted on a wall. After meandering through the lawn, the stream passes beneath a stone bridge and terminates in a lily pond, from where the water is recirculated. The plant collections represent three major eras that have influenced the development of botanical gardens: the Middle Ages, the Age of Exploration, and the Age of Conservation.

The Middle Ages are represented by the Herb Garden and the Physic Garden. During this period, herbs were cultivated for seasonings, dyes, fragrances, and ceremonial purposes. Early physic gardens containing medicinal plants were usually associated with medical schools; their organized collections were the precursors of modern botanical gardens.

During the Age of Exploration, new and valuable plants were collected

from all over the world, and many botanical gardens were established to preserve them. Collections in this area represent plants from the Mediterranean and Middle East, Spanish America, the American South, and Asia (in a section called "The Orient and China"). The Bartram Collection displays plants John and William Bartram found on their travels through the American South. The Ernest Henry Wilson Collection honors a botanist whose expeditions to China introduced more than a thousand species of plants to the Western world. Many of those from southeast China are well adapted for the similar climate of the southeastern United States.

The current age is the Age of Conservation, a time when much of the earth's biodiversity is imperiled and botanical gardens worldwide focus on conserving rare and endangered plants and maintaining plant diversity. The Threatened and Endangered Plants area displays state or federally protected plants; the American Indian Plants section contains plants used by Native Americans of the Southeast; and wetland plants grow in a Bog Garden.

Another major theme garden, the Shade Garden, honors the seven districts of the Garden Club of Georgia. Entered through a wisteria-covered arbor, a gently sloping walkway with handrails provides easy access to a steep hillside under a maturing hardwood forest. Here are displayed the plants for which the districts are named: azaleas, camellias, dogwoods, laurels, magnolias, redbuds, and viburnums. Shade-loving herbaceous plants form a ground cover.

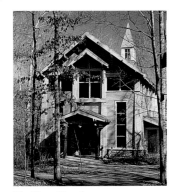

*The Day Chapel*

In the woodland area adjacent to the Shade Garden are two collections. The Dunson Native Flora Garden contains naturalized plantings of more than three hundred species of southeastern native plants, including many rare or threatened ones. The Fred C. Galle Study Collection contains native azaleas.

Grouped beyond a roadway in a sunny open area are a number of special horticultural displays: roses, annuals and perennials, butterfly-attracting plants, All-America Selections, dahlias, and a trial garden for shrubs and trees.

The Day Chapel, a gift in memory of Cecil B. Day Sr., lies on a steep wooded hillside above a stream. With a foundation of Belgian blocks, extensive use of cypress wood in both the interior and the exterior, and beautifully detailed appointments, the chapel is a favorite site for weddings, concerts, and other events. Its grounds have been landscaped with native woodland plants.

The fourth major building, the headquarters of the Garden Club of Georgia, was dedicated in 1998. It contains offices, a conference room, parlors, and a lower level suitable for meetings and large gatherings.

Gardens are intended to grow and change, and the State Botanical Garden of Georgia plans to do just that. A Heritage Garden now under construction, adjacent to the Inter-

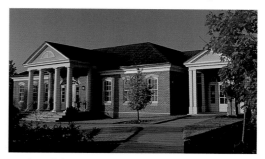

*Garden Club of Georgia Headquarters*

national Garden, will feature plants of economic and historic interest to Georgia. Eventually, a large flower garden incorporating many smaller collections now located elsewhere on the grounds will be built adjacent to the Heritage Garden and the Garden Club Headquarters, completing the major features of the current master plan.

The Garden can be enjoyed in many different ways. It provides beauty for the casual visitor, displays hundreds of plant species, offers classes and seminars for children and adults, accommodates public and private events, provides teacher training and teaching materials on plant conservation and endangered plants, and supports plant research. It is an impressive garden striving to foster appreciation, understanding, and stewardship of plants and nature.

# Spring

WHEN SPRING ARRIVES in the Georgia Piedmont it does not creep in quietly; it bursts forth with a flourish of flowering trees, shrubs, bulbs, and spring ephemerals that transforms the landscape in a few short weeks. At the State Botanical Garden of Georgia, one of the most striking spring displays occurs in the Shade Garden. A wisteria-covered arbor beautifully frames the entry to the sloping ramps that meander down the wooded hillside. Throughout spring the collections in this area create a spectacular scene: viburnums cov-

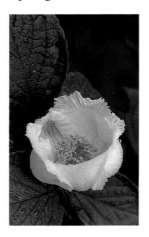

ered with white or pink flower heads, a slope of azaleas, native and cultivated magnolias with showy blooms, redbuds, dogwoods, and an underplanting of daffodils and other spring bulbs.

Many of the native woodland wildflowers bloom in the Dunson Native Flora Garden in spring. Hepatica, bloodroot, and rue anemone are among the first to push up through the cover of fallen leaves. Drifts of golden groundsel appear, contrasting with clumps of bluebells. Many species of trilliums lift their three-petaled flowers above three green leaves. Several rare and protected wildflowers can be seen here, including Oconee bells, ginseng, goldenseal, and twinleaf—the last of these bearing blossoms that last only one day.

Native Piedmont wildflowers can also be seen along the nature trails. The

Orange Trail, passing along a spring-fed creek through pine and hardwood forest to the Middle Oconee River, is an interesting spring wildflower walk. Mayapple, bellwort, Jack-in-the-pulpit, and wild geranium are just a few of the species that can be found.

Spring is a good time to visit the Day Chapel. Landscaped with native plants, its grounds are set off by the white flowers of dogwood, fothergilla, and foam flower.

Many areas in the International Garden are in bloom by midspring. In the American South Collection, fringe trees and a silverbell lift their white flowers above native azaleas in shades of yellow, orange, and red, and blooms of sun-loving perennials border the walk-way. In the Ernest Henry Wilson Collection of plants introduced from China, rhodo-dendrons, Kurume azaleas, and Japanese pieris thrive. And in the sunny Herb Gar-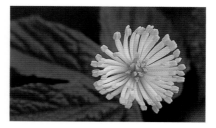den, the shy blue flowers of borage and the bold yellows of yarrow make their appearance.

The Annual/Perennial area begins to flower at this time, too. A wonder-fully gnarled cherry tree dominates the area with its cascades of pale pink flowers. A bed of Siberian iris provides a swath of deep blue. In the border, spiderwort, yarrow, foxglove, and evening primrose provide a colorful mix, and by late May, the adjacent rose garden is bursting with bloom.

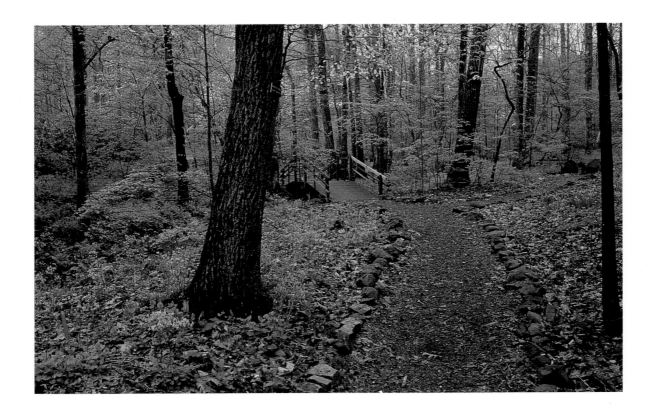

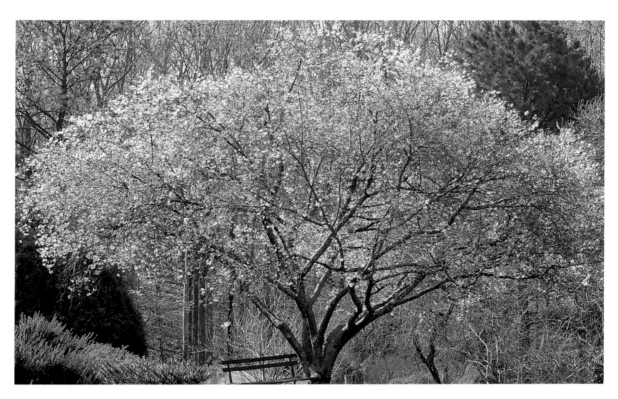

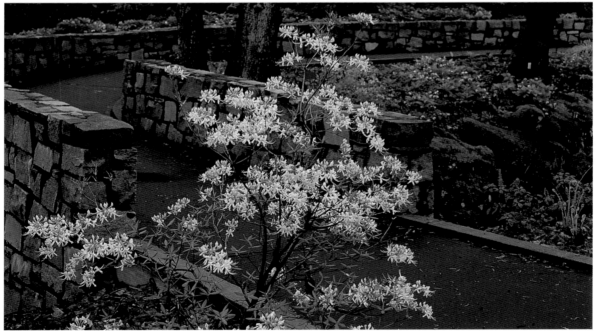

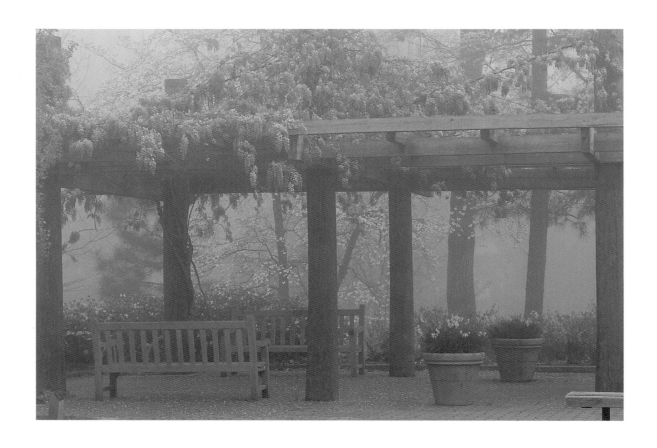

Chinese wisteria (*Wisteria sinensis*) arbor in fog

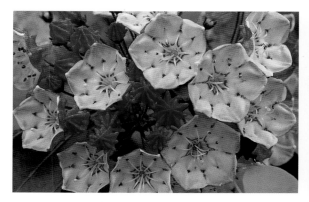

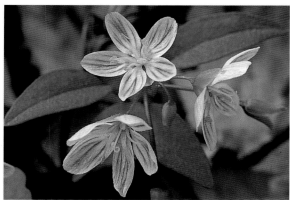

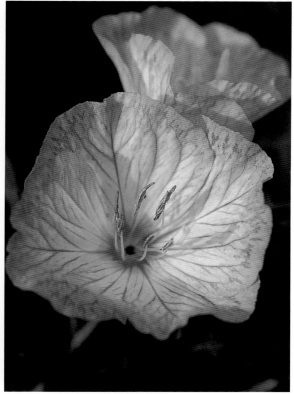

CLOCKWISE, FROM UPPER LEFT

Mountain laurel (*Kalmia latifolia* 'Nipmuck')

Showy evening-primrose (*Oenothera speciosa* 'Siskiyou')

Carolina spring beauty (*Claytonia caroliniana*)

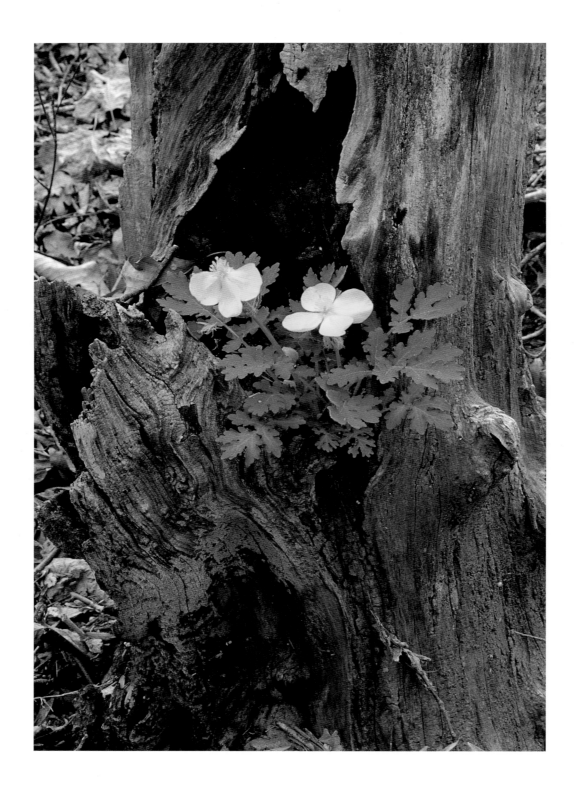

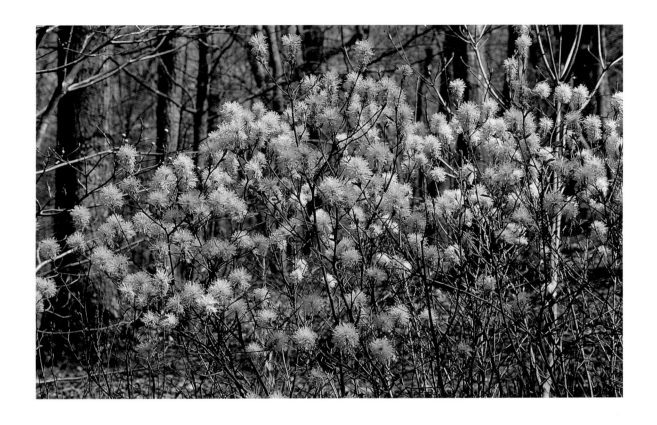

FACING PAGE
Celandine poppy (*Stylophorum diphyllum*)

ABOVE
Dwarf fothergilla (*Fothergilla gardenii*), a threatened plant

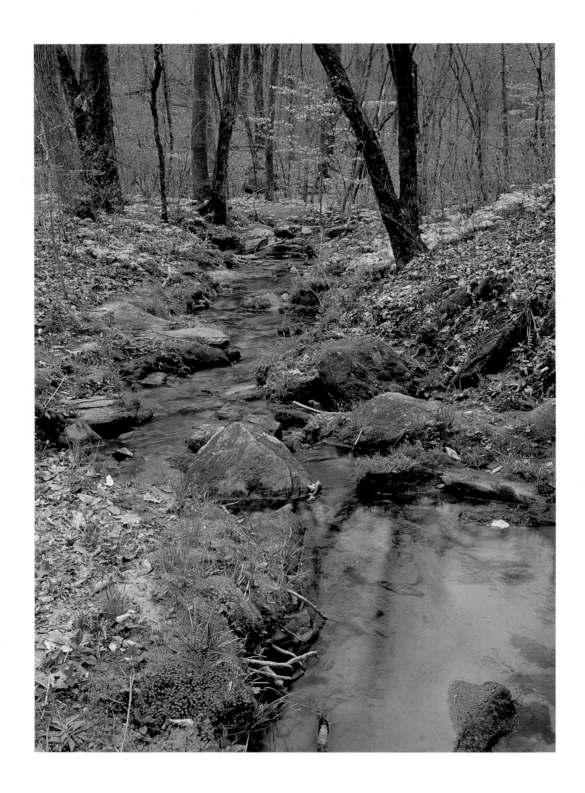

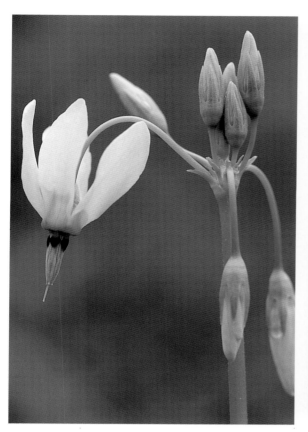 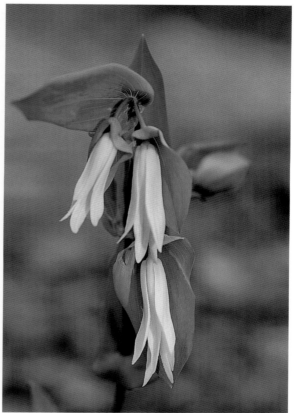

FACING PAGE

A view along the Orange Trail

ABOVE, LEFT TO RIGHT

Shooting star (*Dodecatheon meadia*)

Bellwort (*Uvularia perfoliata*)

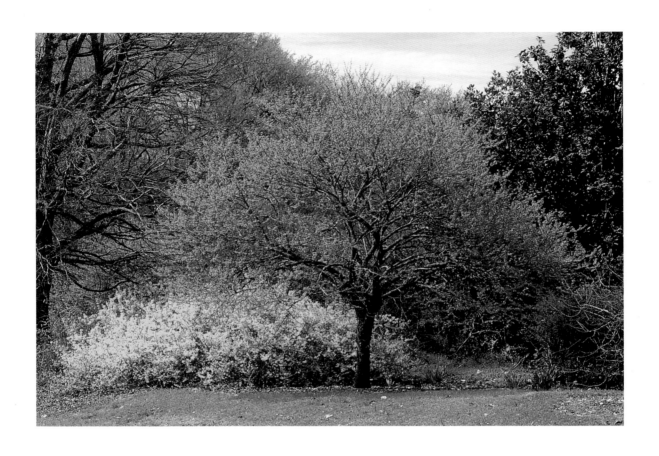

Eastern redbud (*Cercis canadensis*) and forsythia (*Forsythia* x *intermedia*) at entrance

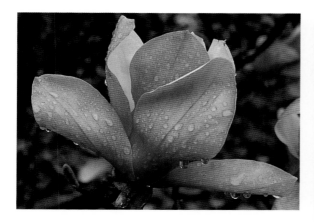

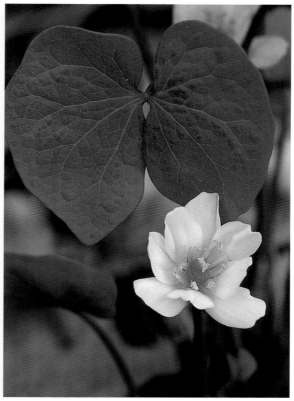

CLOCKWISE, FROM ABOVE LEFT

Saucer magnolia (*Magnolia* x *soulangiana* 'Alexandrina')

Twinleaf (*Jeffersonia diphylla*), a rare and endangered plant

Green-and-gold (*Chrysogonum virginianum*)

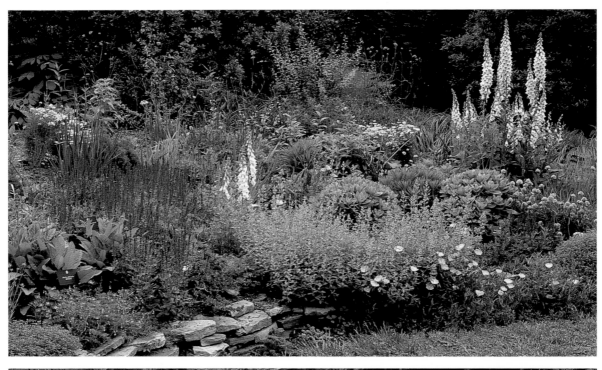

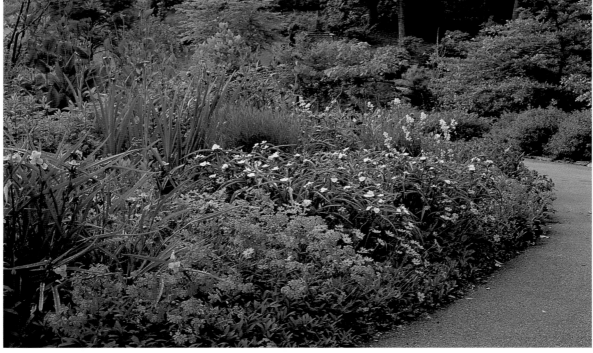

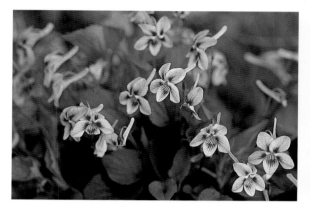

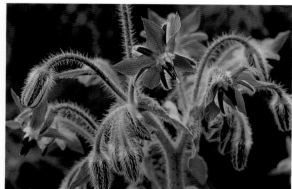

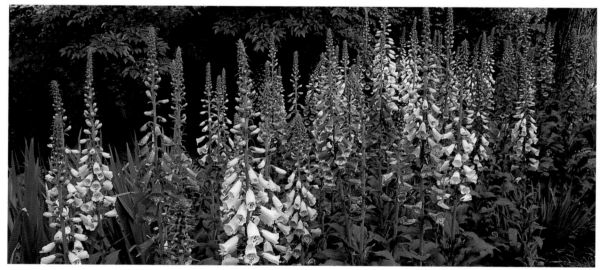

The Annual/Perennial Garden
The American South section of the International Garden

Long-spurred violet (*Viola rostrata*)
Borage (*Borago officinalis*)
Common foxglove (*Digitalis purpurea*)

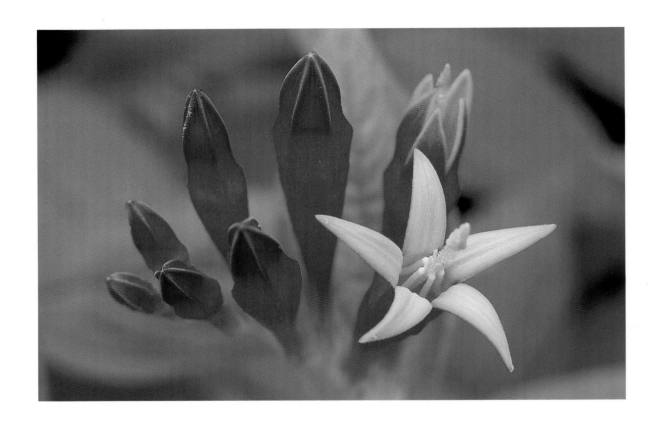

ABOVE
Indian pink (*Spigelia marilandica*)

FACING PAGE
Red-hot poker (*Kniphofia uvaria*)

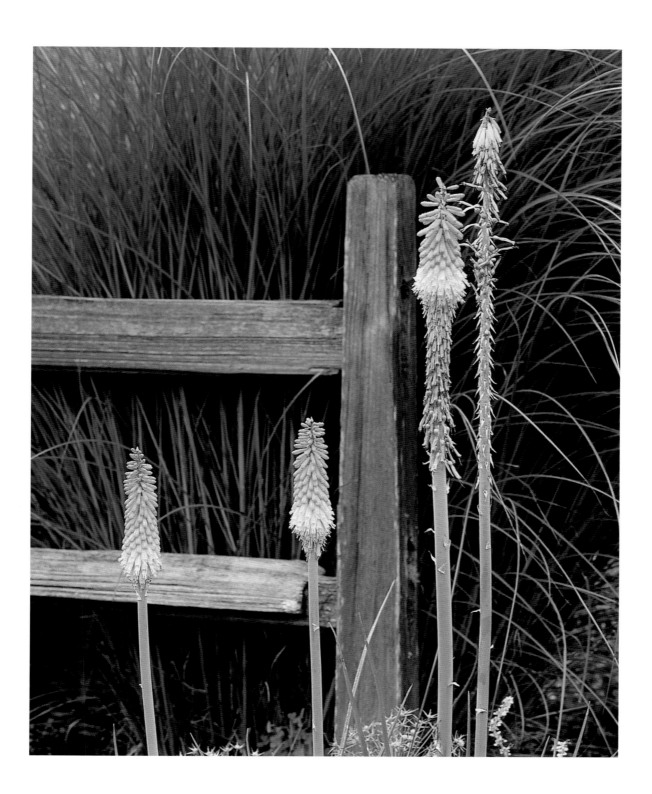

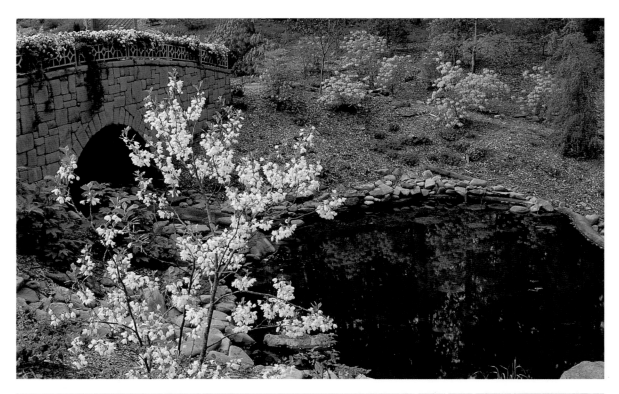

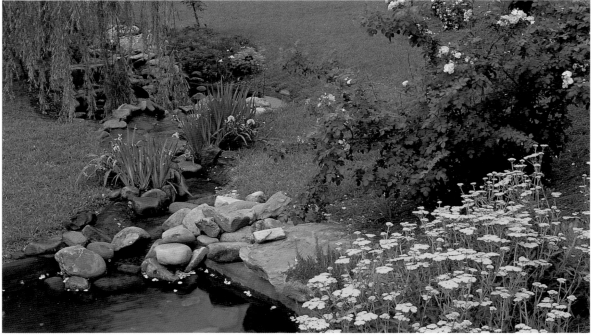

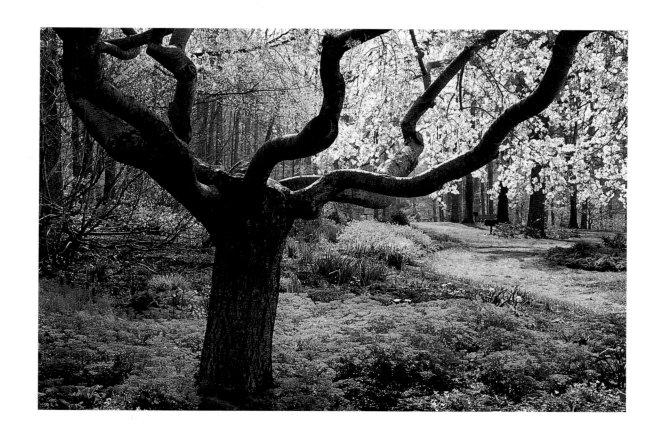

FACING PAGE, TOP TO BOTTOM
Two-winged silverbell (*Halesia diptera* var. *magniflora*)
Yarrow (*Achillea*), Rose (*Rosa*), and iris (*Iris*)

ABOVE
Cushion spurge (*Euphorbia polychroma*) under a cherry tree

OVERLEAF
Azaleas (*Rhododendron*) in morning fog

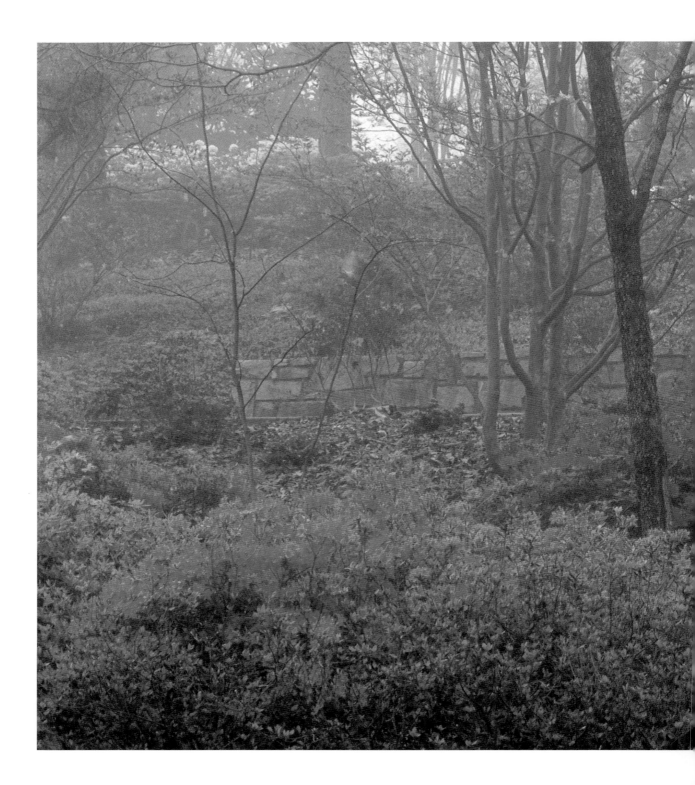

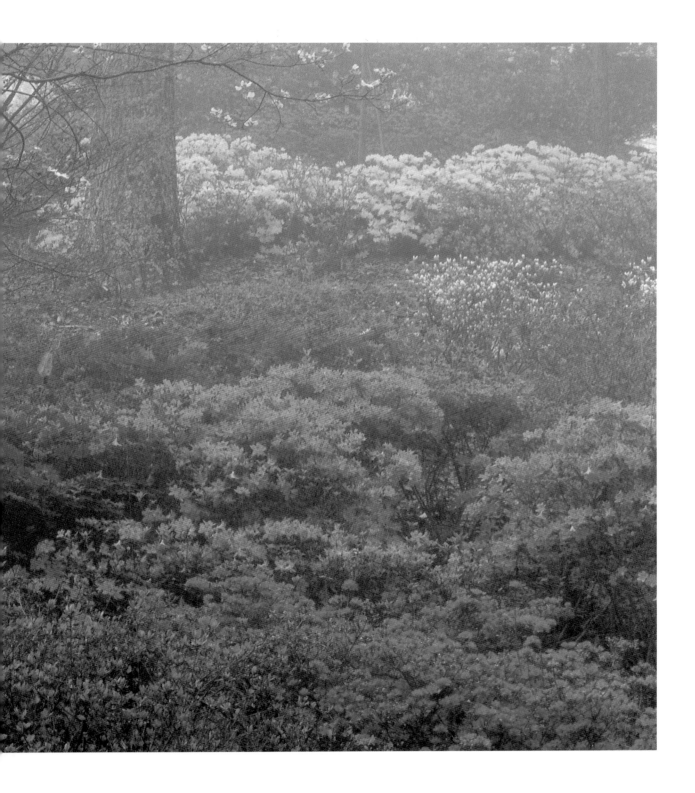

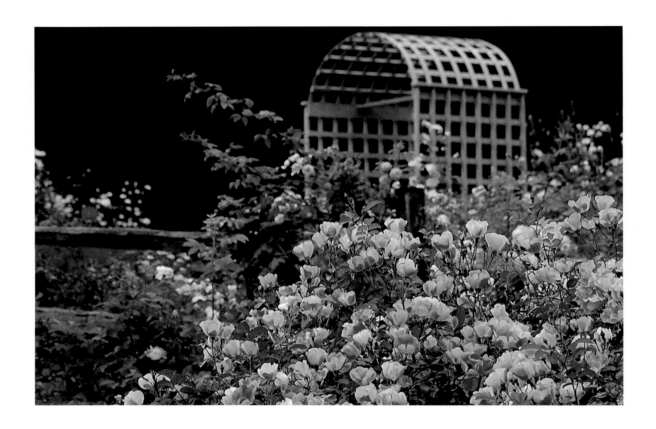

The Rose Garden

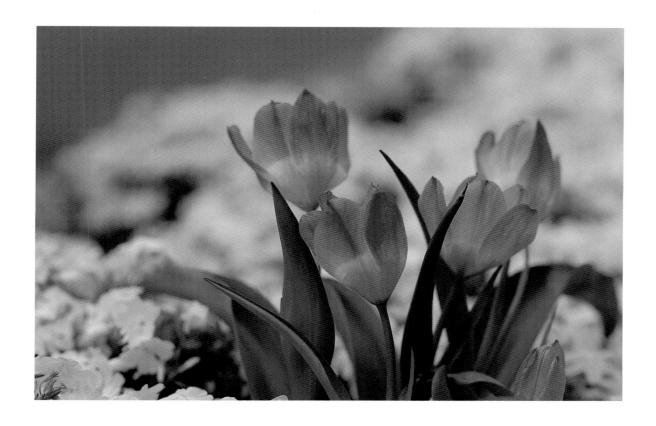

ABOVE

Tulip (*Tulipa* 'Lilac Wonder')

FOLLOWING PAGES

Sweet William (*Dianthus barbatus*) with a lily lantern in the Physic Garden

Overview of the Herb Garden

Overview of the Herb Garden from the pavilion of the Visitor Center

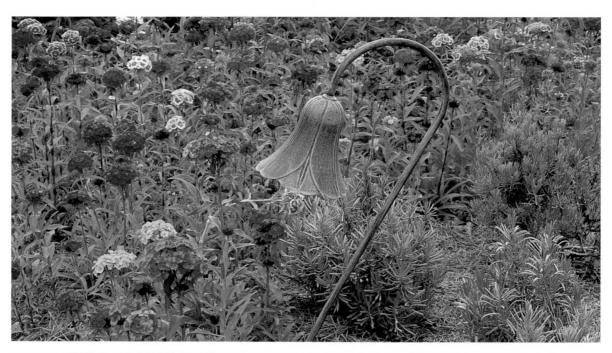

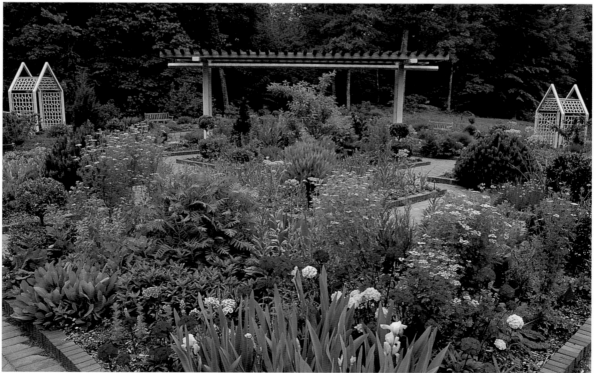

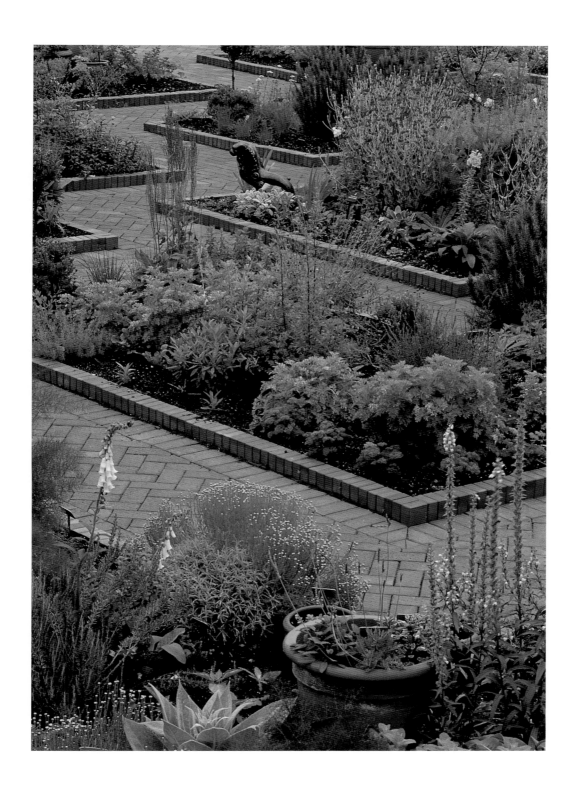

Newly emerged leaves and flower bud of painted buckeye (*Aesculus sylvatica*)
along the Orange Trail

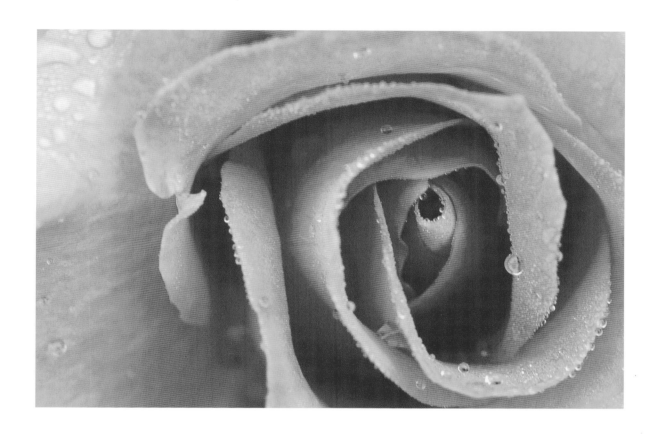

Rose (*Rosa floribunda* 'Brass Band')

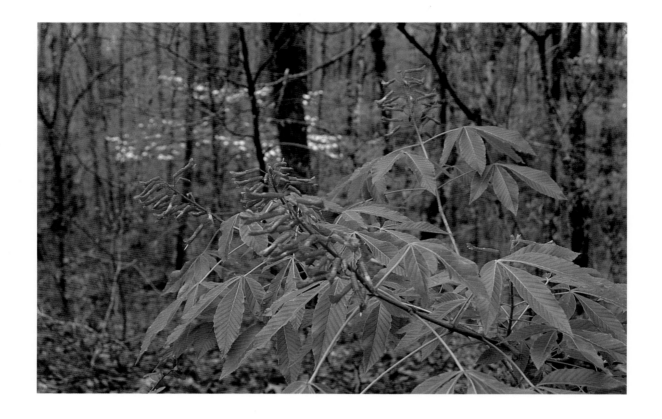

ABOVE
Red buckeye (*Aesculus pavia*) in the woods near the Callaway Building

FACING PAGE
Chinese snowball (*Viburnum macrocephalum*)

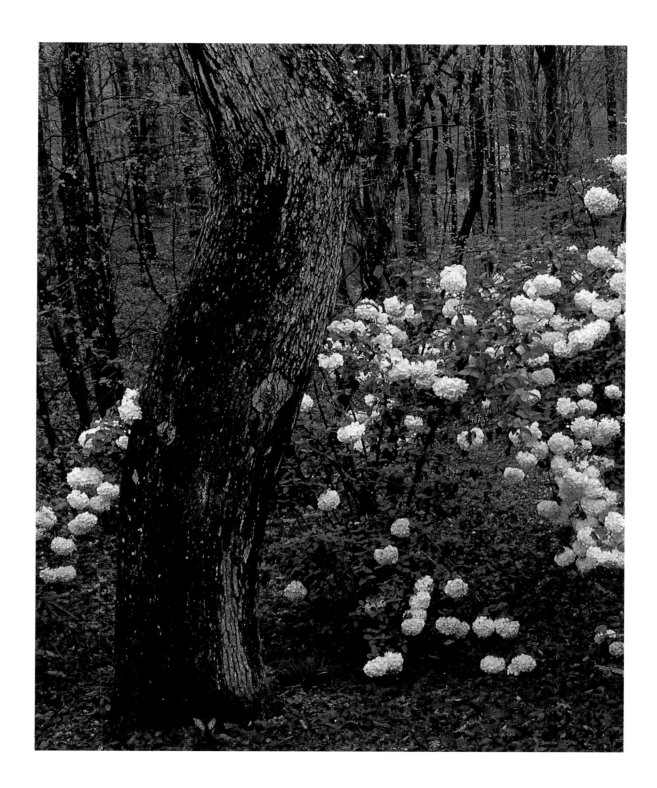

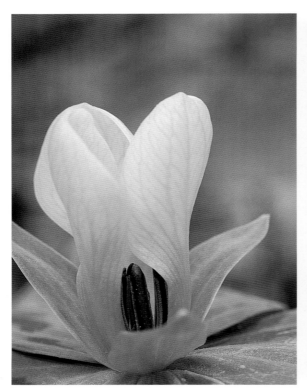 

ABOVE, LEFT TO RIGHT
Pale yellow trillium (*Trillium discolor*)
Alabama pinkroot (*Spigelia gentianoides* var. *alabamensis*),
an Alabama rare and endangered plant

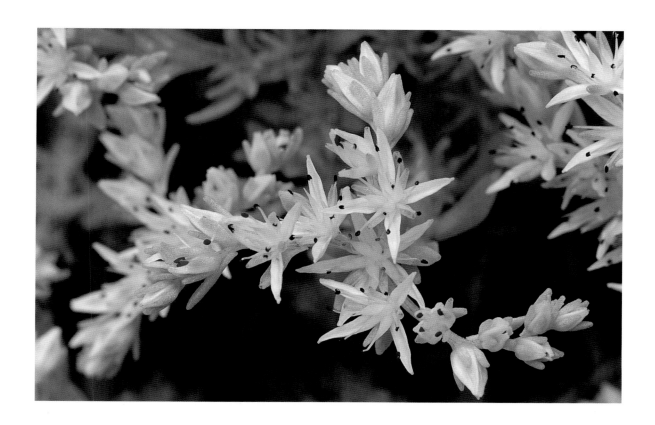

Stonecrop (*Sedum glaucophyllum*)

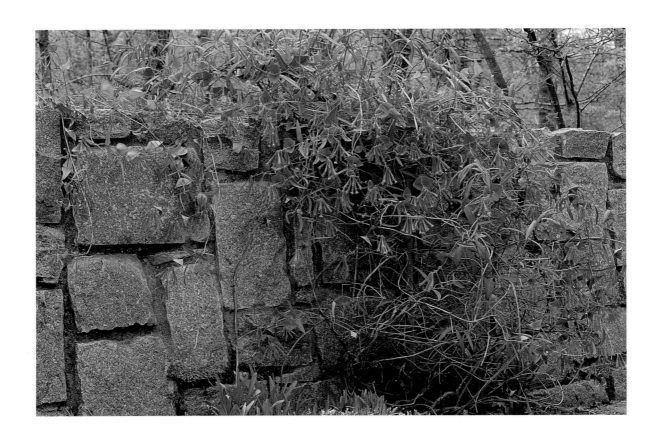

Coral honeysuckle (*Lonicera sempervirens*)

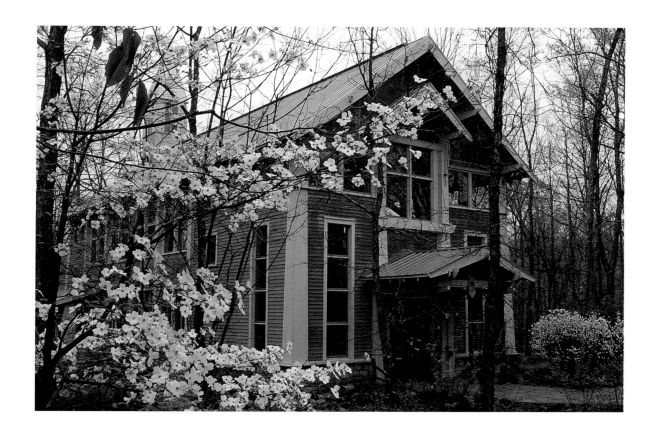

The Day Chapel surrounded by dogwood (*Cornus florida*) and dwarf fothergilla (*Fothergilla gardenii*), the latter a threatened plant

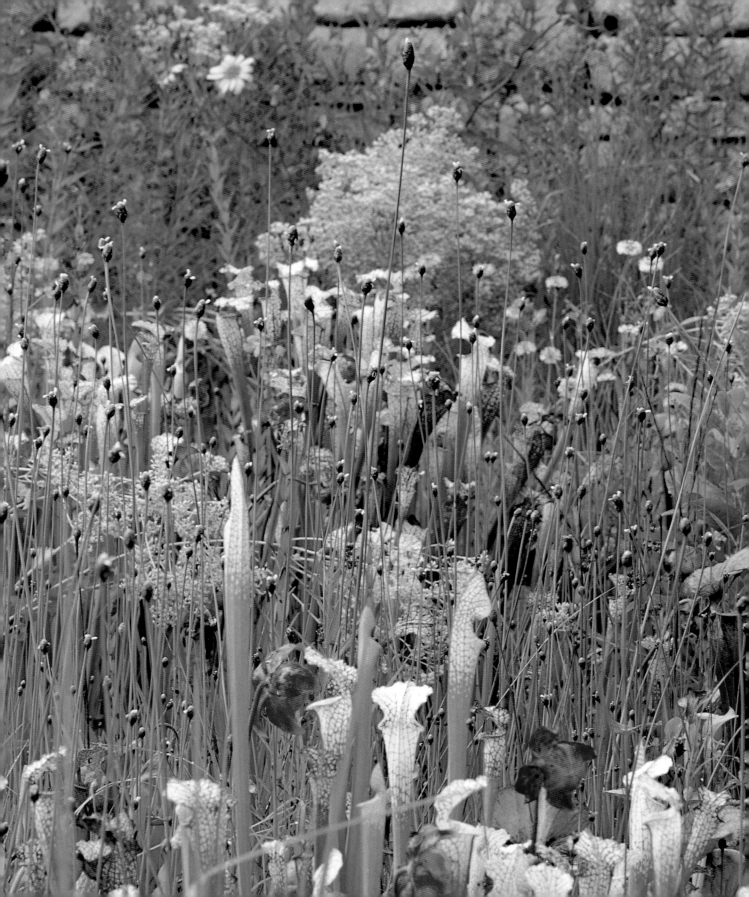

*Summer*

By the time the trees have fully leafed out, many of the plants in the shady areas of the Garden have finished blooming. The annuals and perennials in the sunnier areas are now the stars of the show.

The International Garden is at its best in summer. In addition to flowers, the Herb and Physic Gardens display leaves in a variety of textures and hues and provide enticing aromas such as mint, rosemary, and dill. In the Spanish American section grow examples of food crops originating in that area— corn, peppers, and beans—with an edging of bright zinnias and marigolds. The turf of the central lawn takes on a lush green color, and a selection of ornamental grasses, lilies, and Joe Pye weed borders the stream. In the Bog Garden pitcher plants, interspersed with pink meadow beauties and yellow-eyed grass, raise their colorful leaves to snare insects.

Beds of bright annuals predominate in the All-America Selections display area. Plants vary from year to year but often include marigolds, zinnias, celosias, cosmos, and rudbeckias in shades of red, yellow, and orange. Many daylily cultivars fill an extensive bed nearby, and a mixed border of annuals and perennials combines varied colors, textures, and shapes.

Throughout the Garden, seasonal plantings fill containers and planters.

Sometimes they feature a color-coordinated display, with flowers all in shades of lavender and purple, or pinks and reds. Shadier spots may have plants with colorful leaves, such as coleus and caladiums.

A stroll along the Middle Oconee River on the Orange and White Trails can be delightful in midsummer. The water slips by with a gentle murmur, cicadas sing, the leaves of tall maples, sycamores, and oaks shade the trail, and seed heads of native grasses nod in the breeze.

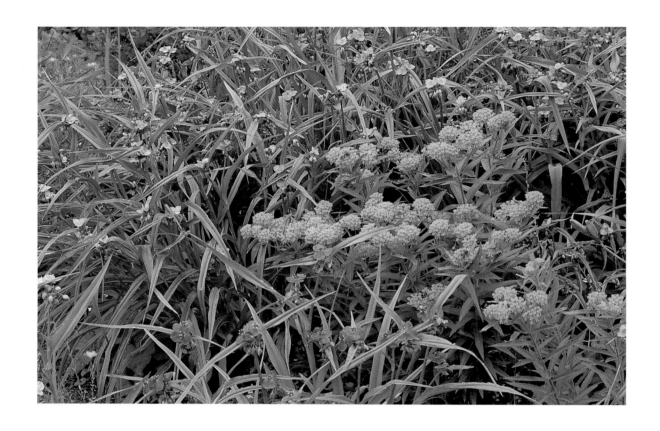

PRECEDING PAGES
A pitcher plant bog, page 34
Wax mallow (*Malvaviscus arboreus* var. *drummondii*), page 36

ABOVE
Butterfly weed (*Asclepias tuberosa*) and spiderwort (*Tradescantia virginiana*)

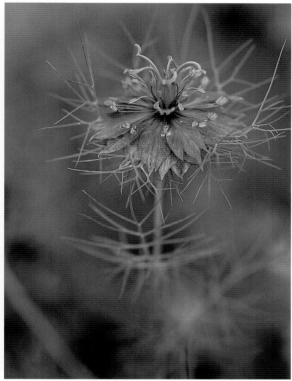

LEFT TO RIGHT

Ocmulgee skullcap (*Scutellaria ocmulgee*), a threatened plant

Love-in-a-mist (*Nigella damascena*)

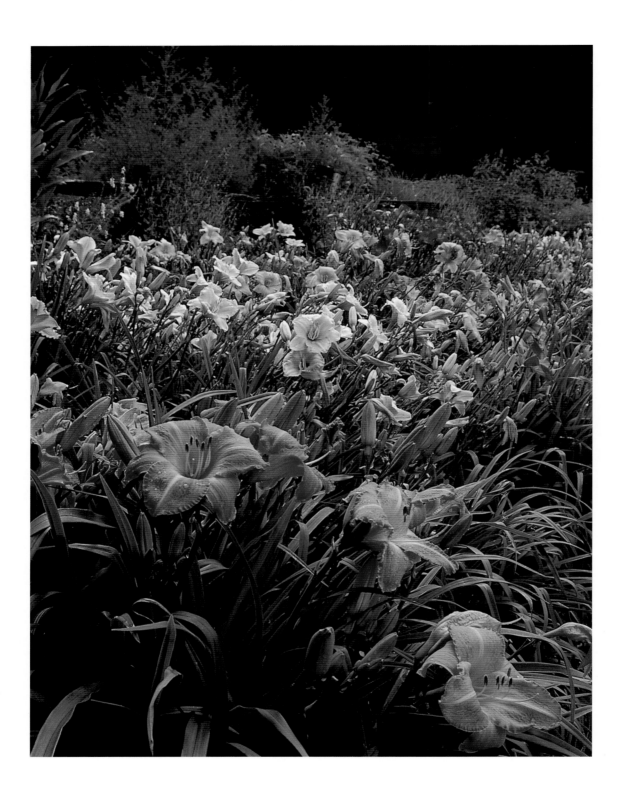

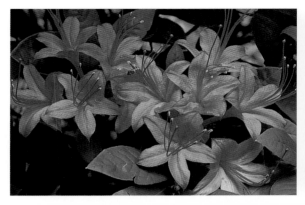

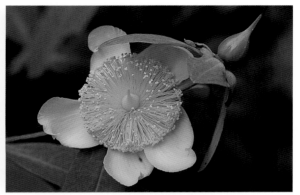

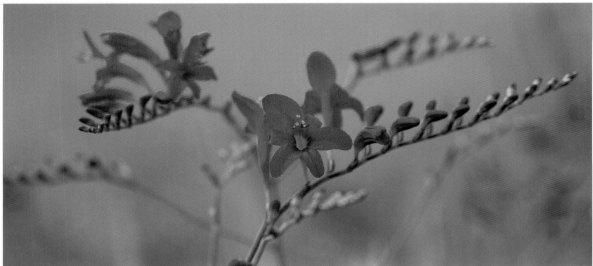

FACING PAGE
Daylilies (*Hemerocallis*)

CLOCKWISE FROM UPPER LEFT
Plumleaf azalea (*Rhododendron prunifolium*), a threatened plant
Showy St. John's wort (*Hypericum frondosum*)
Crocosmia (*Crocosmia* 'Lucifer')

FOLLOWING PAGES
Loblolly bay (*Gordonia lasianthus*)
Easter lily (*Lilium longiflorum*) along the stream in the International Garden

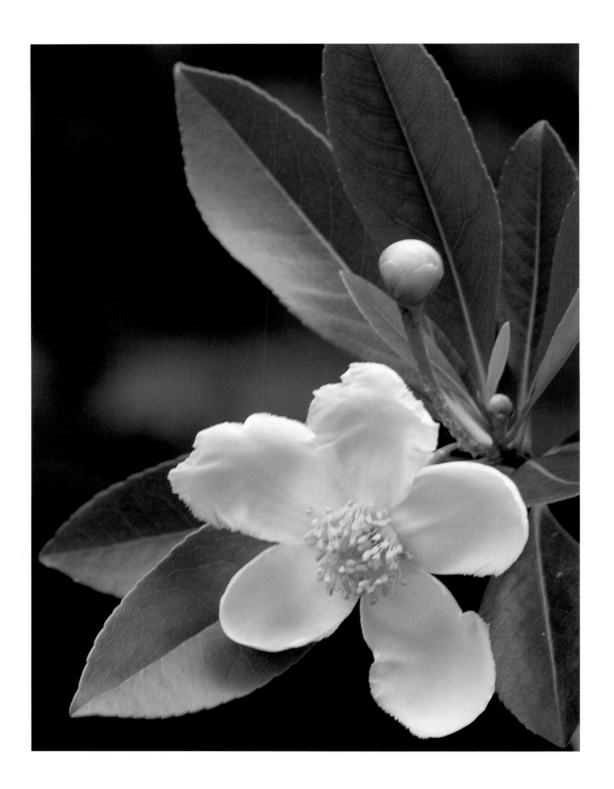

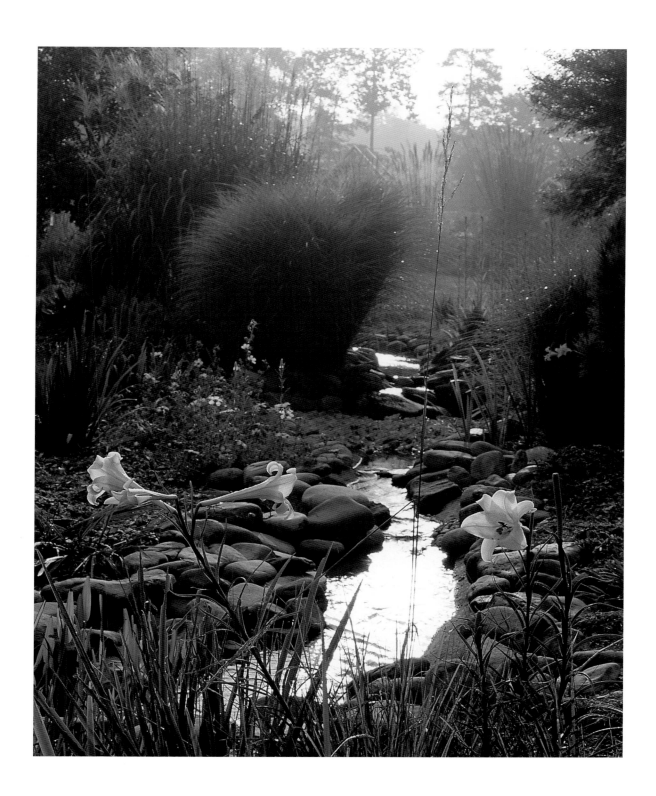

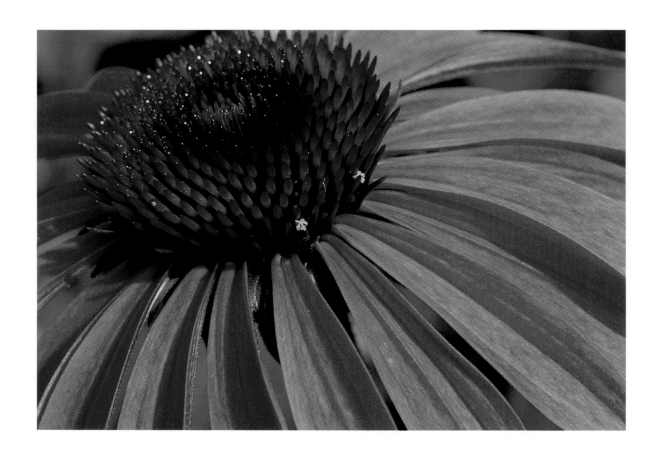

ABOVE

Purple coneflower (*Echinacea purpurea*)

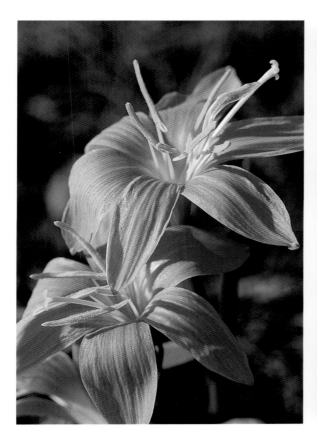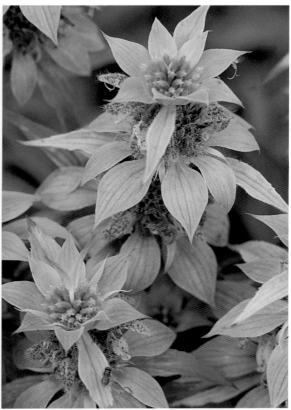

ABOVE, LEFT TO RIGHT
Pink rain-lily (*Habranthus robustus*)
Spotted bee-balm (*Monarda punctata*)

FOLLOWING PAGES
The Annual/Perennial Garden
The Annual/Perennial Garden border
Cockscomb (*Celosia argentea*)

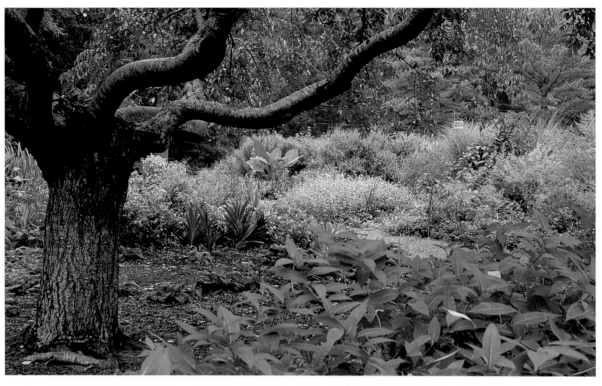

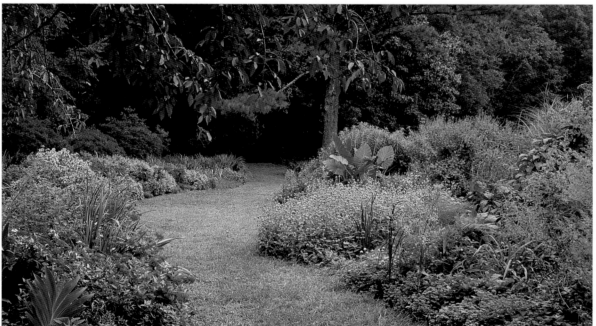

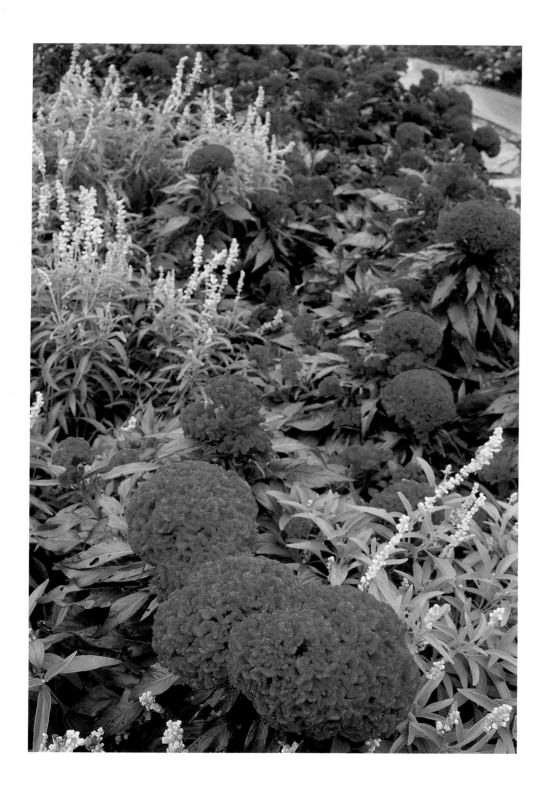

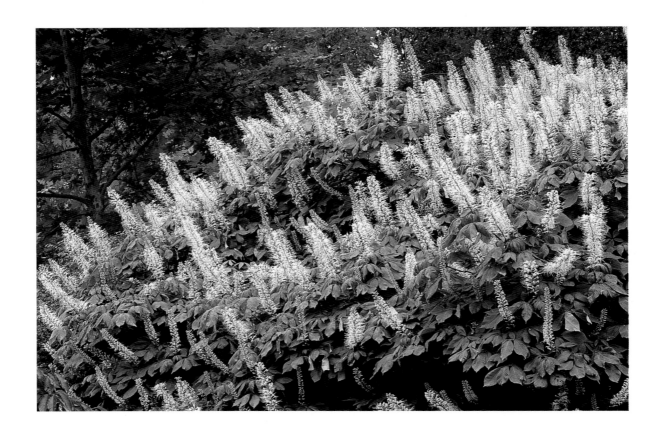

Bottlebrush buckeye (*Aesculus parviflora*) flowers

Joe Pye weed (*Eupatorium fistulosum*)
Blazing star (*Liatris spicata*)

Visitor Center and pavilion from the flower bridge

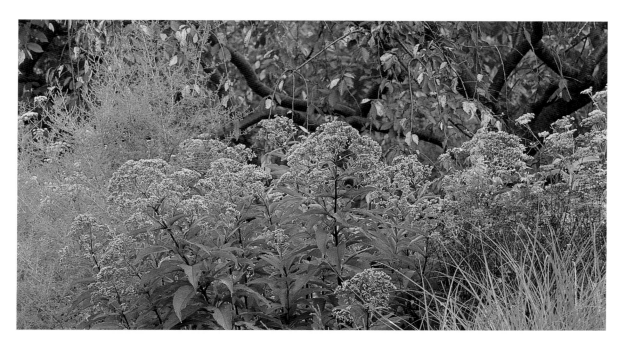

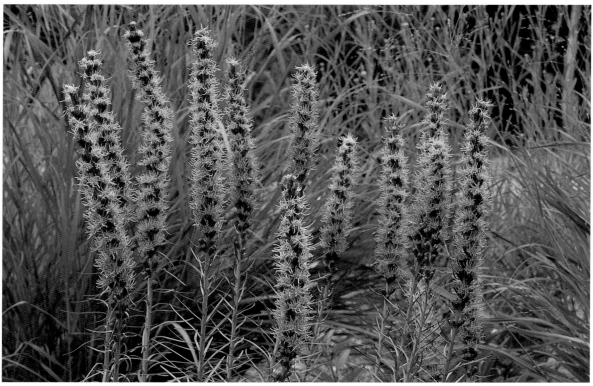

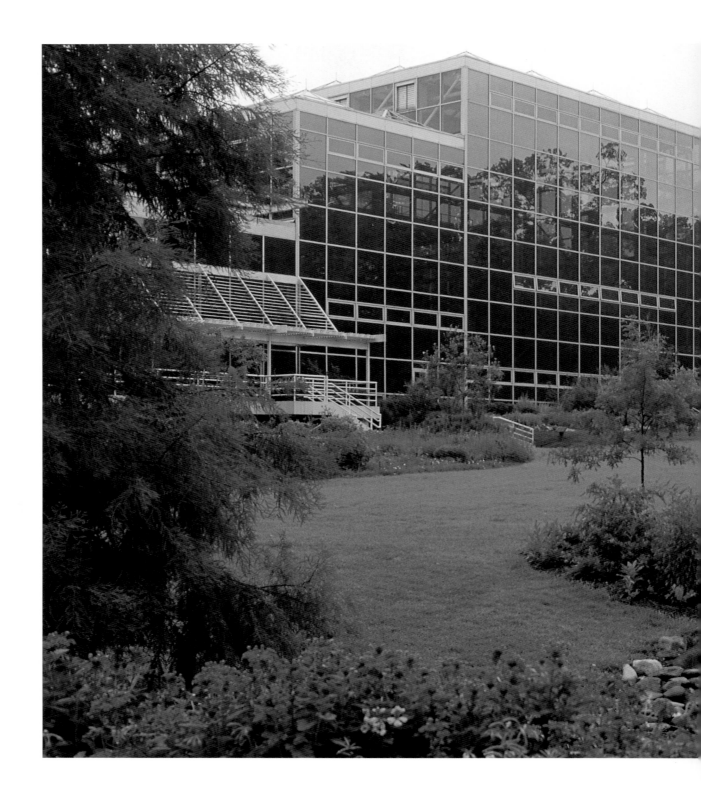

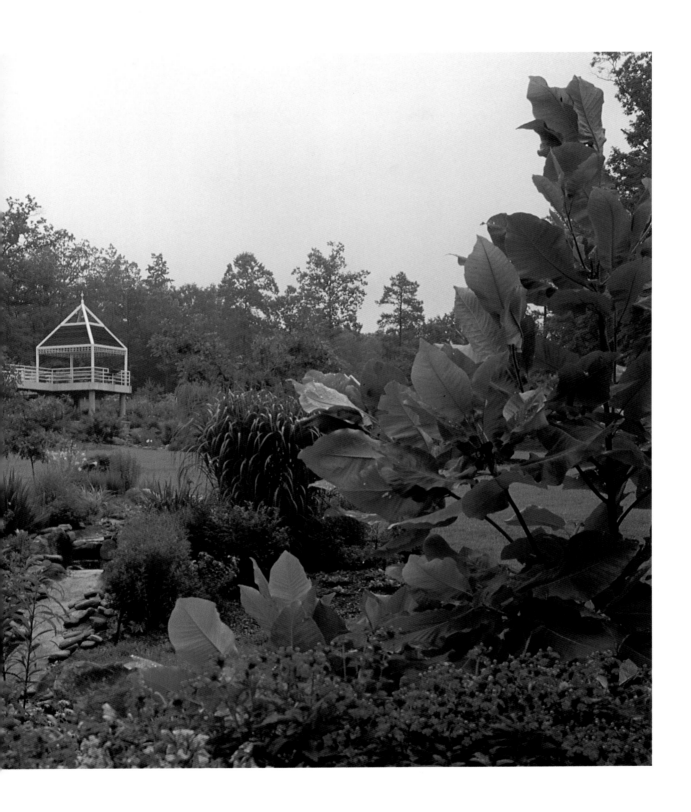

ABOVE
Bottlebrush buckeye (*Aesculus parviflora*) with seed pods

FACING PAGE
Dill (*Anethum graveolens*) and feverfew (*Tanacetum parthenium*)

OVERLEAF
All-America Selections: zinnias (*Zinnia*), cockscomb (*Celosia*),
cosmos (*Cosmos*), black-eyed Susan (*Rudbeckia*)

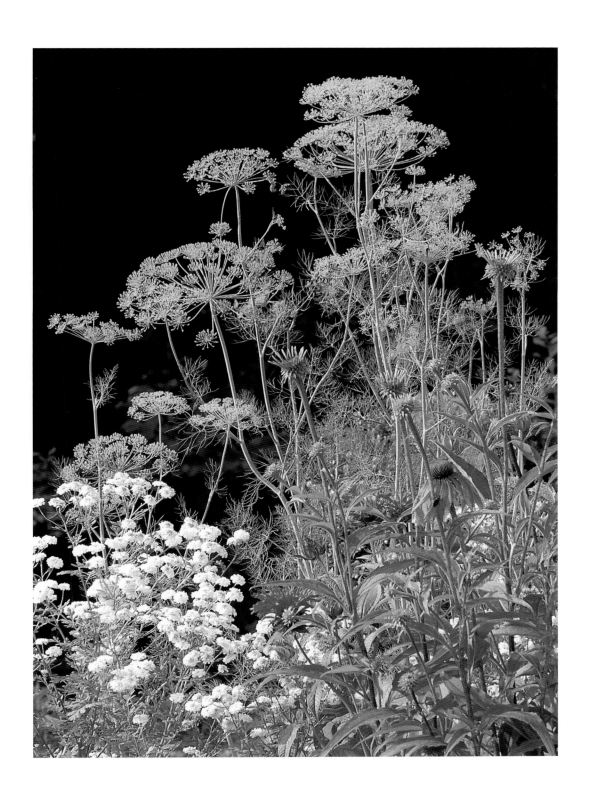

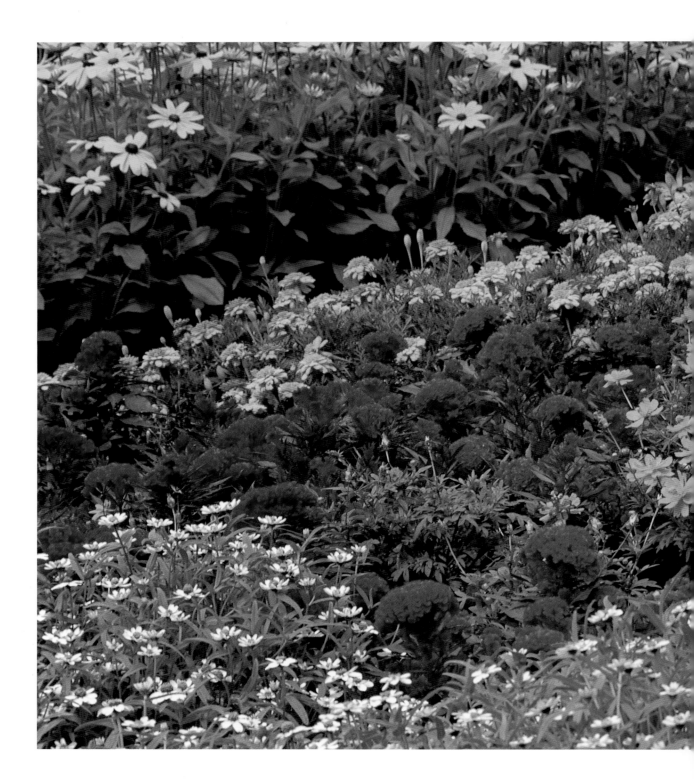

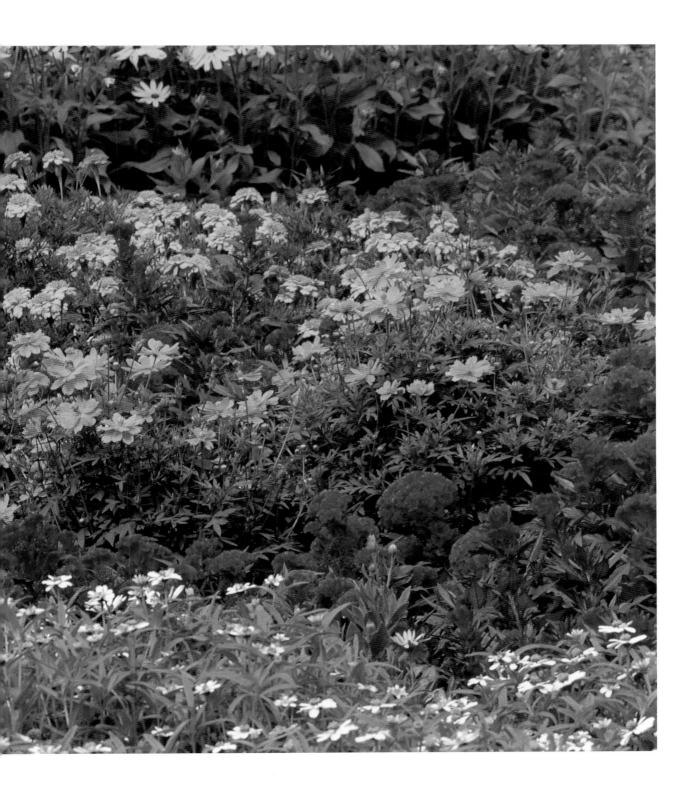

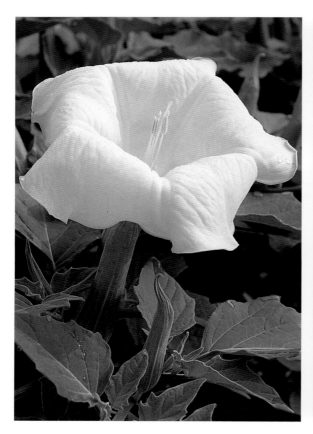 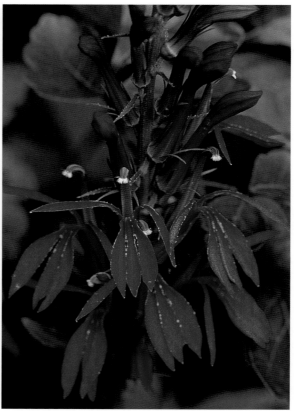

ABOVE, LEFT TO RIGHT
Pricklyburr (*Datura inoxia*)
Cardinal flower (*Lobelia cardinalis*)

FACING PAGE
Sunflower (*Helianthus annuus*)

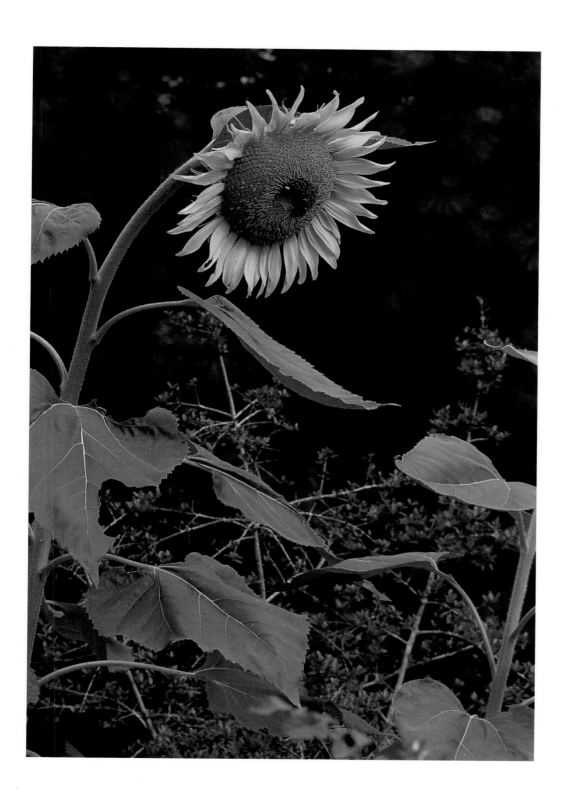

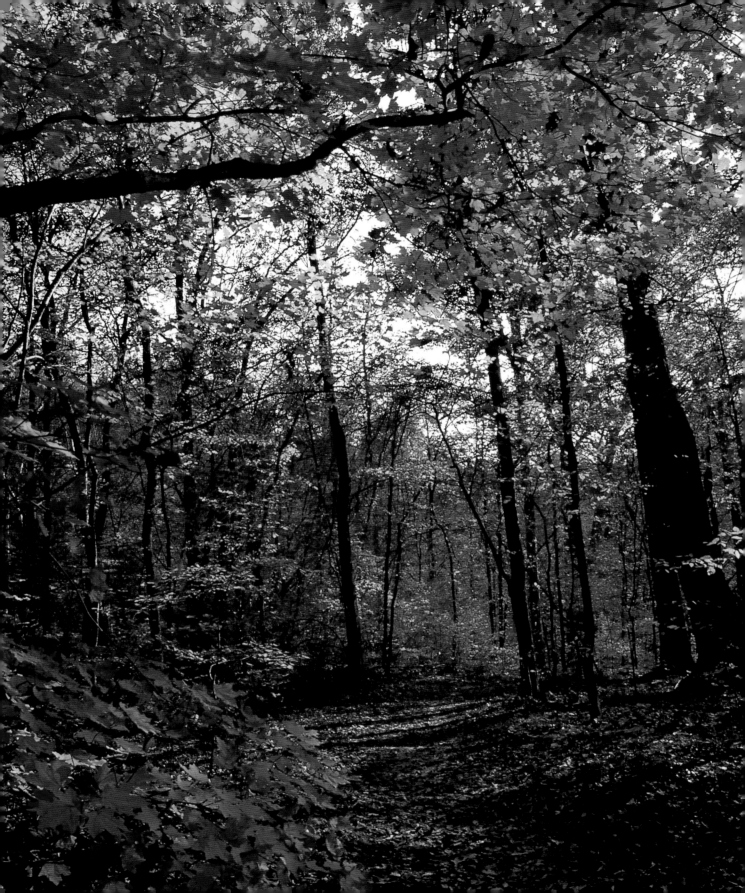

# Autumn

ALTHOUGH MANY PLANTS have finished flowering and gone to seed by the beginning of autumn, some first come into bloom at this time. Toad lilies flower in the Shade Garden, ginger lilies and turmeric in the Annual/Perennial area, swamp sunflower in the Dunson Native Flora Garden, and red spider lilies, with blooms on long leafless stalks, in the International Garden. The dahlia collection provides a spectacular display of most types and colors of dahlias. A bed of pink chrysanthemums borders the ornamental stream in the central lawn.

Many summer-blooming plants such as zinnias, salvias, and asters continue flowering in seasonal beds and borders until the first frost. The butterfly garden is a thicket of tall yellow, red, and purple flower stalks, visited by eastern tiger swallowtail butterflies and ruby throated hummingbirds. Sedum 'Autumn Joy' and purple flamingo feathers flourish in 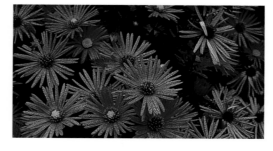 the Annual/Perennial border, and a few late blossoms dot the Rose Garden.

But at this season the center of interest begins to shift from flowers to foliage, seeds, and fruit. Japanese maples turn bright crimson at the entrances to the Visitor Center, Callaway Building, and Shade Garden. In a shrub border, burning bush lives up to its name with masses of orange-red leaves. De-

ciduous hollies sport berries of red, orange, and yellow, and foliage of Virginia sweetspire provides shades of maroon. Near the Dunson Native Flora Garden, native piedmont grasses glow golden in the sunlight against a backdrop of brilliant orange sumac.

Along the nature trails, piedmont hardwoods put on their annual fall show. Oaks, hickories, red maples, dogwoods, black gums, and sweetgums ensure a range of colors. The waters of the river, streams, and garden ponds reflect the vivid foliage colors, while drifts of fallen leaves paint the ground.

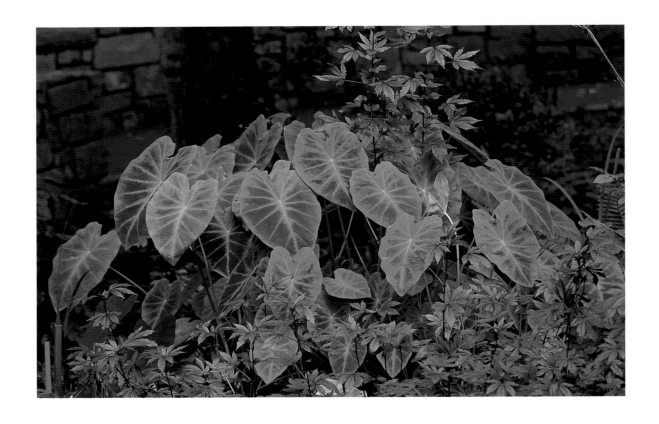

ABOVE
Taro (*Colocasia esculenta*)

FACING PAGE, ABOVE AND BELOW
Overview of one of the beds in the Annual/Perennial Garden
Chrysanthemums (*Chrysanthemum*) by a stream

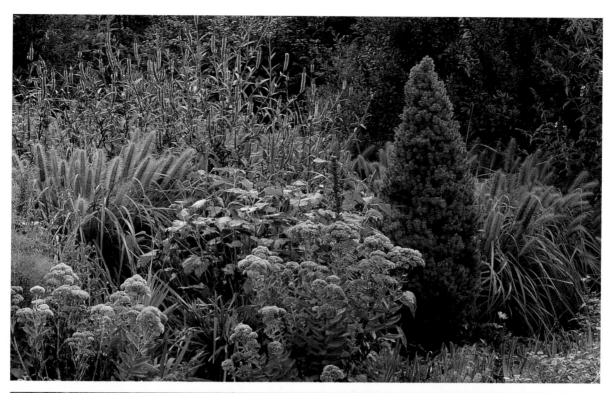

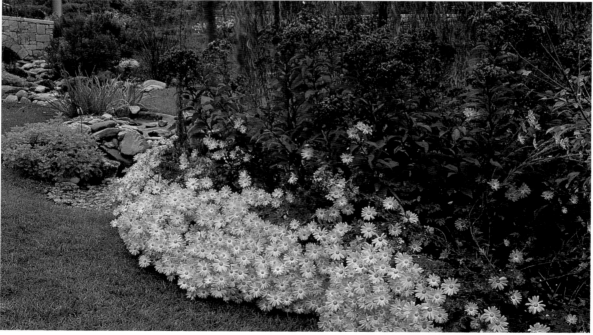

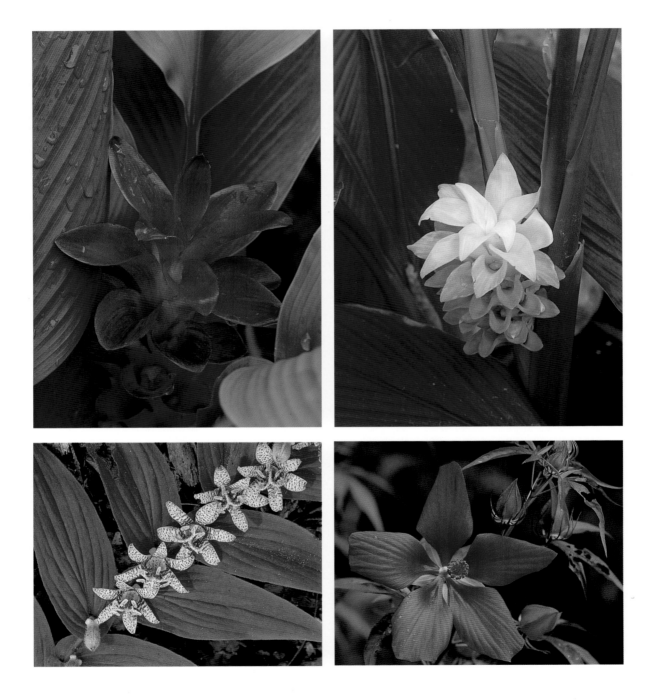

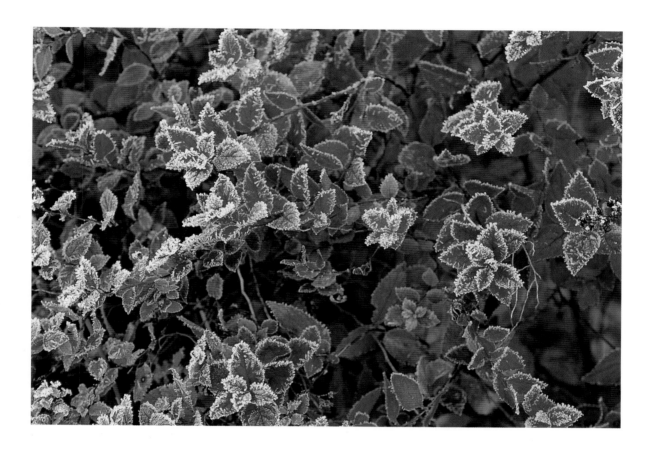

FACING PAGE, CLOCKWISE FROM UPPER LEFT
Ginger lily (*Curcuma australasica*)
Turmeric (*Curcuma longa*)
Scarlet rosemallow (*Hibiscus coccineus*)
Toad lily (*Tricyrtis hirta* 'Miyazaki')

ABOVE
Japanese spiraea (*Spiraea japonica* 'Gold Mound') after a frost

OVERLEAF
The Butterfly Garden

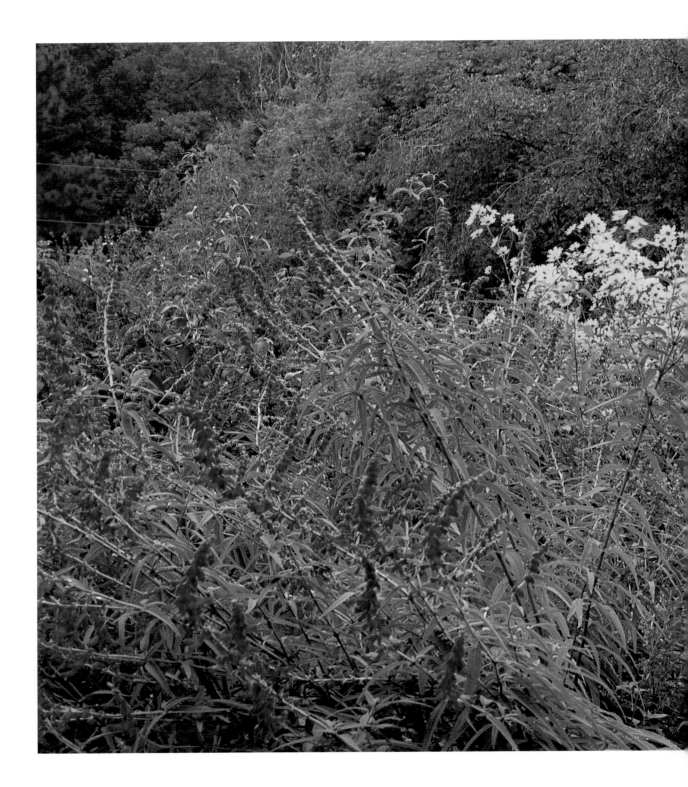

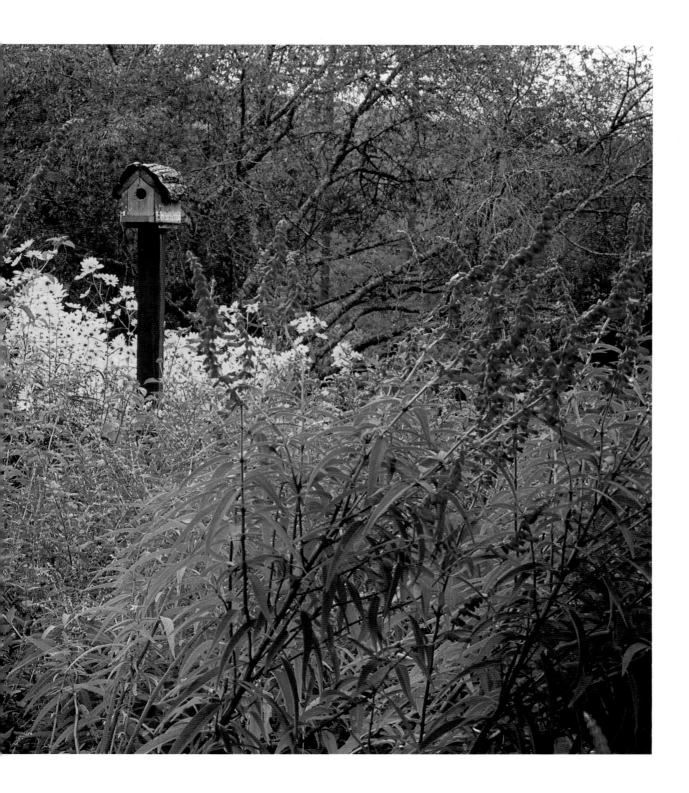

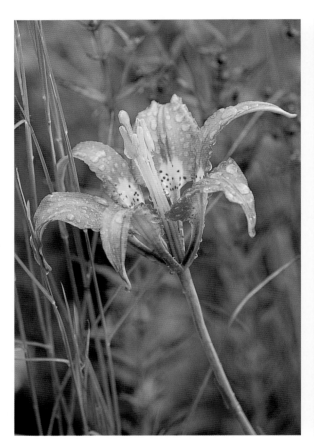

ABOVE, LEFT TO RIGHT

Pine lily (*Lilium catesbaei*)

Box elder (*Acer negundo*) stems beside the Middle Oconee River

FACING PAGE

Fall reflections on the Orange Trail

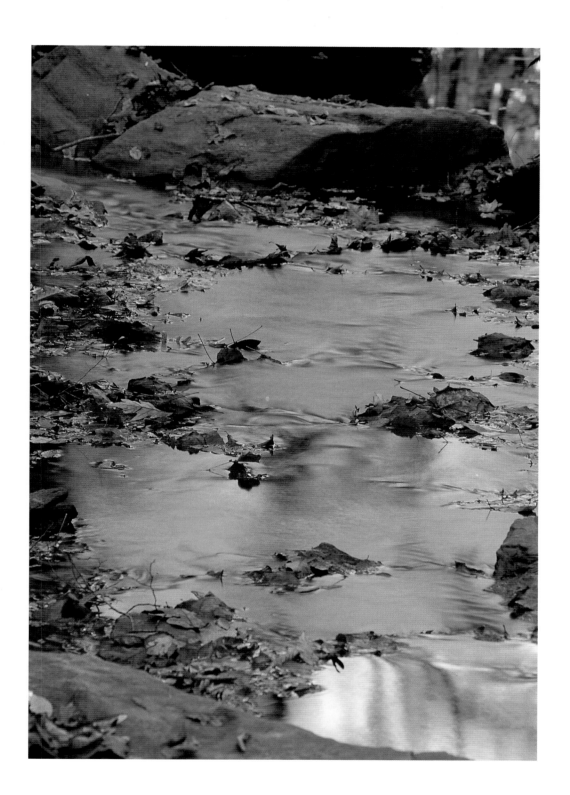

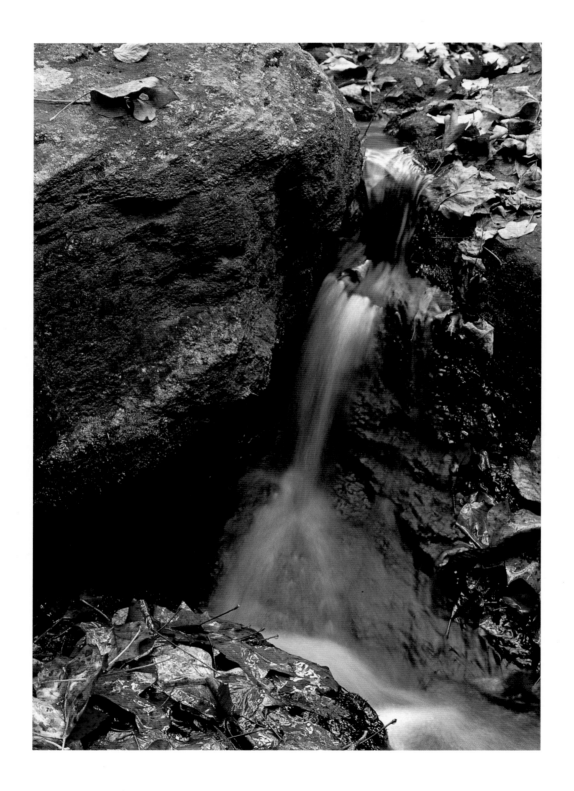

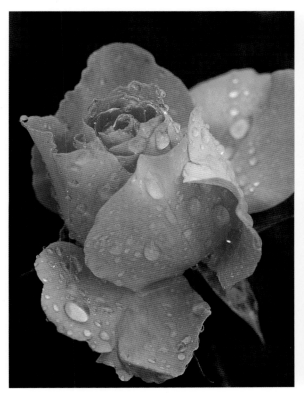

FACING PAGE
Small cascade on the White Trail

ABOVE, LEFT TO RIGHT
Rose (*Rosa floribunda* 'Brass Band')
Tall stewartia (*Stewartia monadelpha*)

OVERLEAF
Sumac (*Rhus*)

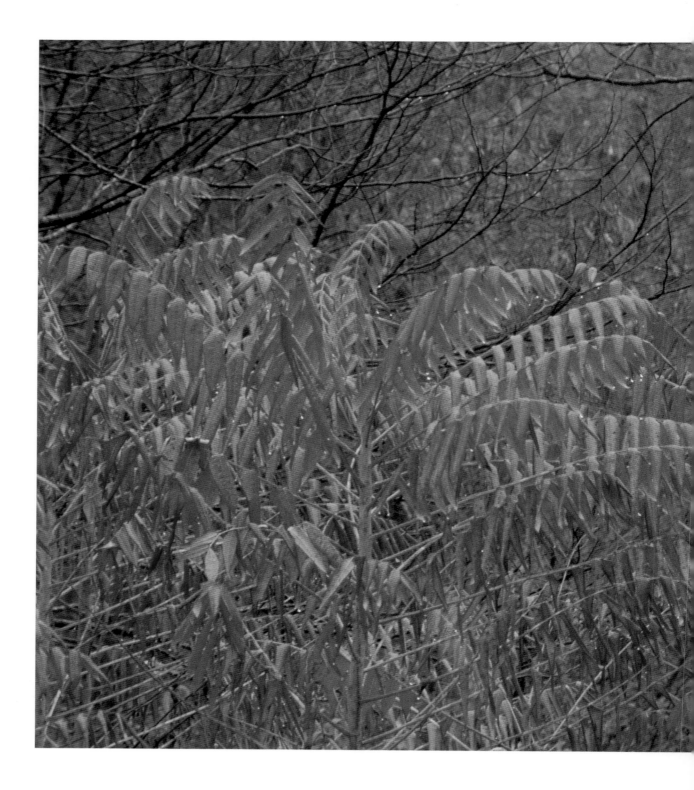

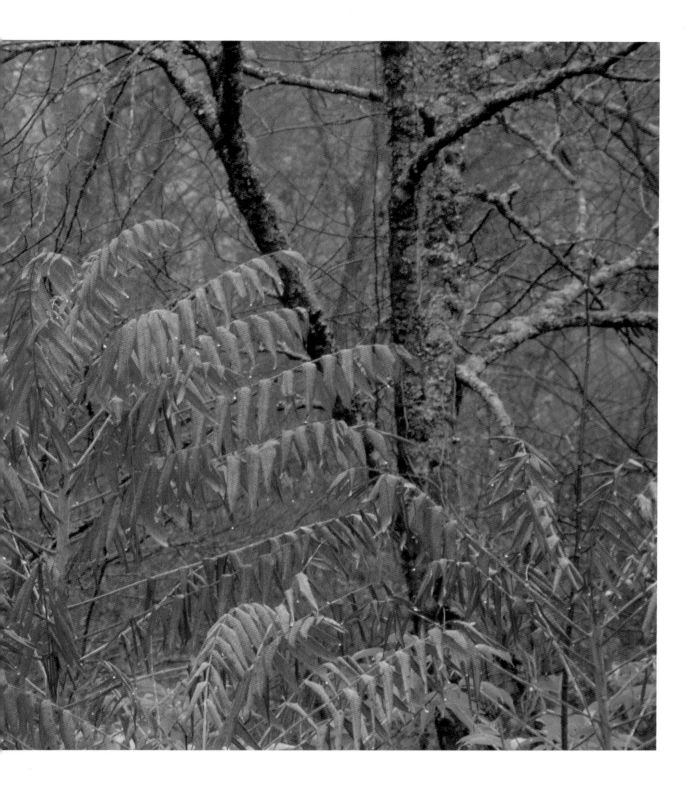

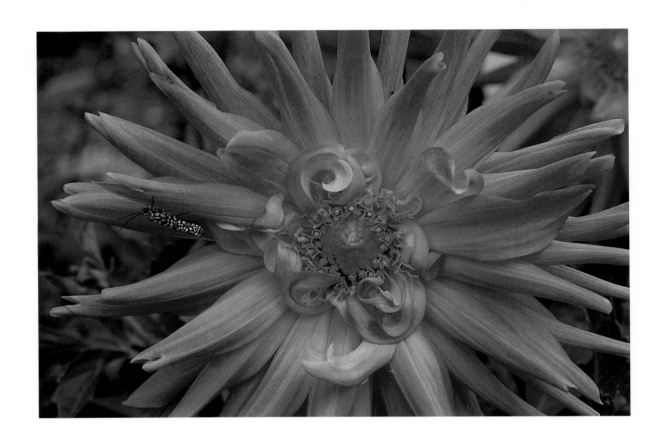

Dahlia (*Dahlia* 'Classic Al')

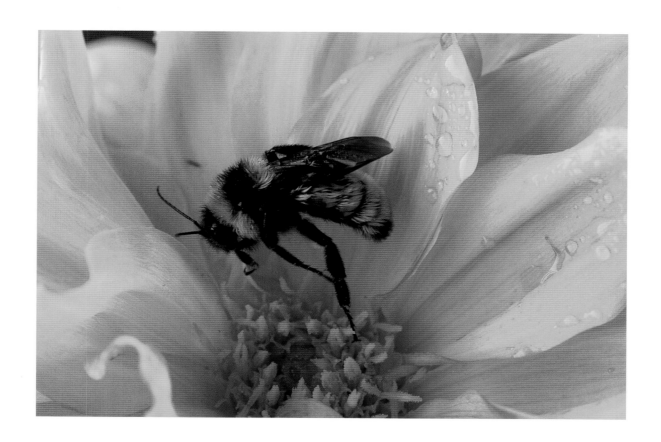

Dahlia (*Dahlia* 'Ben Hudson') with bee

Thunberg lespedeza (*Lespedeza thunbergii*) and amur maple
(*Acer tataricum*, var. *ginnala*) in the Trial Garden

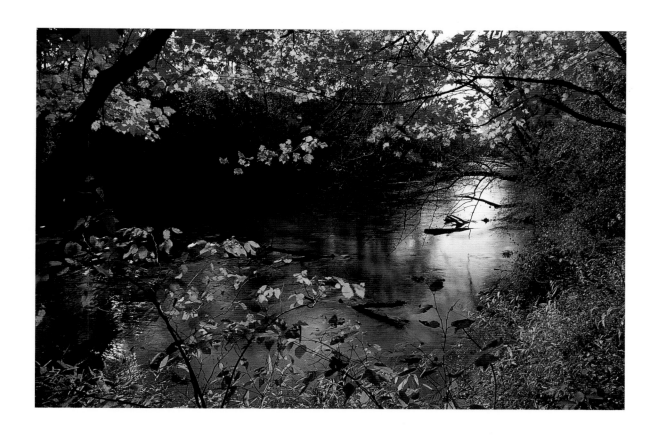

Fall foliage along the Middle Oconee River on the Orange Trail

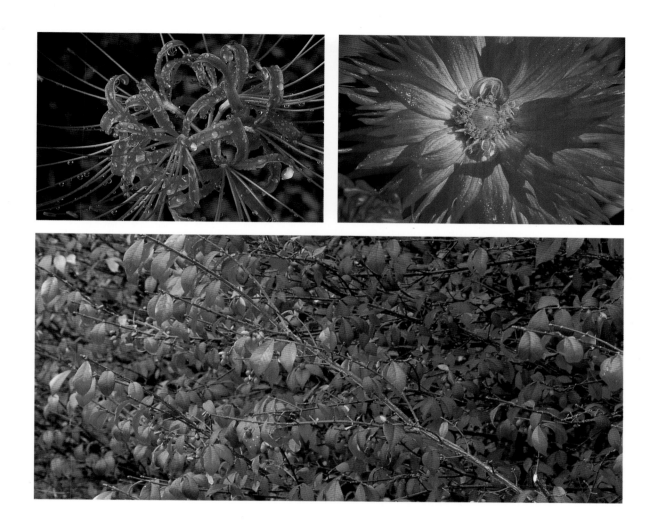

FACING PAGE
Winterberry (*Ilex serrata* x *I. verticillata* 'Sparkleberry')

ABOVE, CLOCKWISE FROM UPPER LEFT
Red spider lily (*Lycoris radiata*)
Dahlia (*Dahlia* 'Cheyenne')
Burning bush (*Euonymus alatus* 'Compactus')

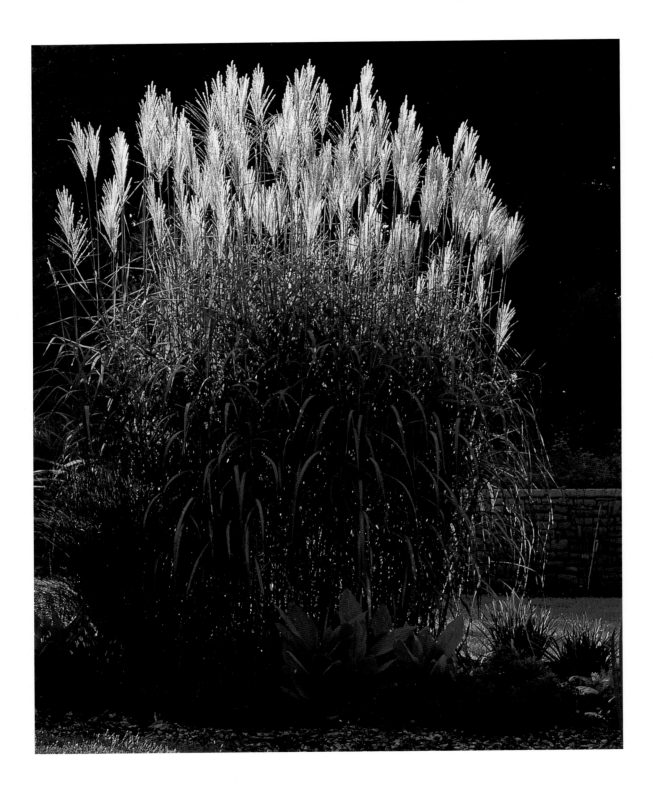

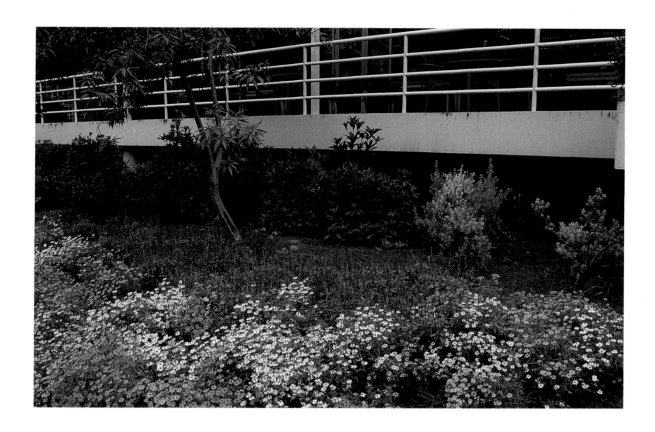

FACING PAGE

Eulalia grass (*Miscanthus sinensis* 'Cosmopolitan')

ABOVE

Zinnias (*Zinnias*) and sages (*Salvias*) by the Visitor Center

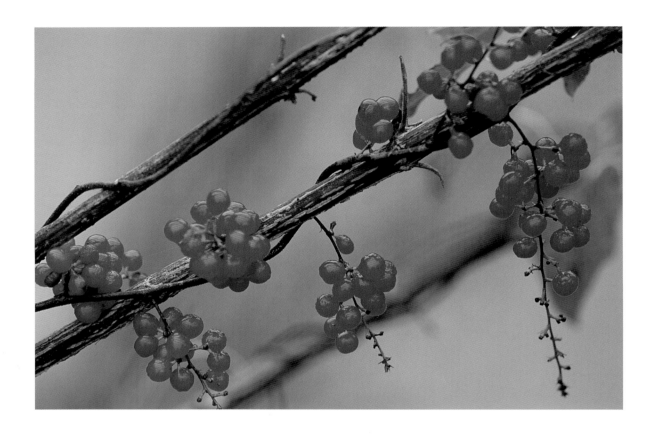

ABOVE
Coralbeads (*Cocculus carolinus*)

FACING PAGE, ABOVE AND BELOW
Row of Japanese maples (*Acer palmatum*) along the path to the Visitor Center
Piedmont grass meadow

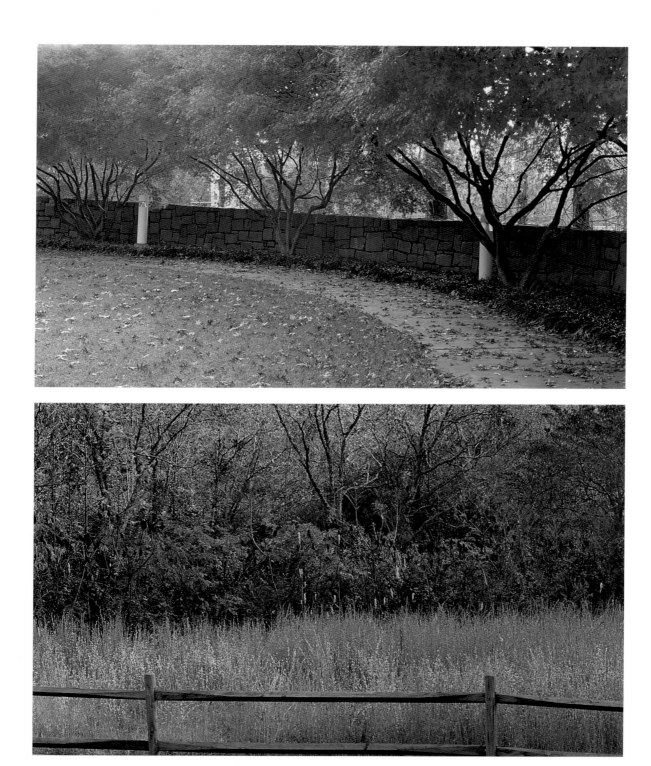

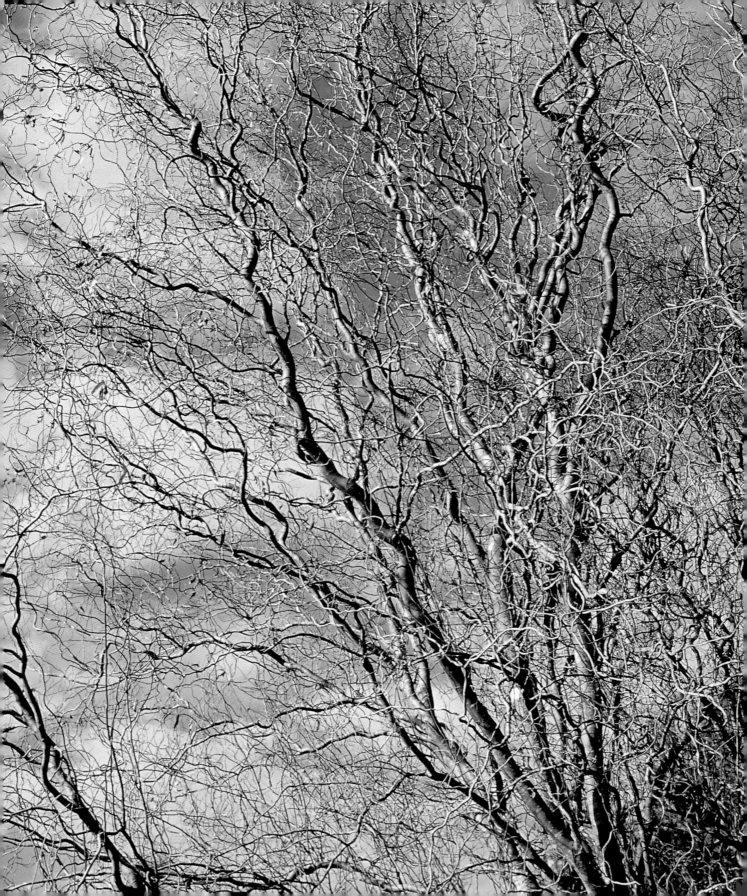

# Winter

DURING THE WINTER MONTHS, color is less dominant in the Garden. It is a time to savor the visual effects of lines, forms, and textures. Bare deciduous trees and shrubs show off their structures, some reaching skyward, some branching horizontally, and others pendulous. Developing catkins dangle from the wonderfully contorted branches of Harry Lauder's walking stick. The bark of river birches, sycamores, paperbark maples, and crape myrtles peels off in fascinating plates and curls, exposing a variety of subtle colors. Garden structures stand out more clearly: the arch of a bridge, the curve of a walk, the texture of a stone wall.

In the natural areas, the contours of the land are more visible in winter. One can easily see how a stream has eroded its banks, detoured around a boulder, cut a new channel to the river, or spread out behind a beaver dam. The beavers are not often seen, but gnawed stumps are easy to find.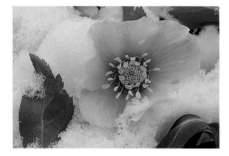

A rare winter snowfall can transform the Garden. It coats the needles of conifers and clings to the persisting tan leaves on young American beeches. It emphasizes the shape of the knot garden and turns an agave into an icy sculpture. Sun emerging from the clouds makes snow-clad twigs and branches sparkle.

Of course, there is still some color in the Garden. A few of the red berries

on hollies and pyracanthas have escaped being eaten by the birds. The scarlet feathers of a male cardinal stand out against the somber landscape as he forages for remaining berries and seeds. Some ornamental conifers have variegated foliage in shades of yellow and light green. Pansies planted in the autumn now bloom in containers and beds, and other late winter flowers soon appear. It is fun to search for the first hepatica on the Orange Trail, lenten roses and camellias in the Shade Garden, or bluebells in the Dunson Native Flora Garden. And before long, the magnolias are budding, ready to welcome spring.

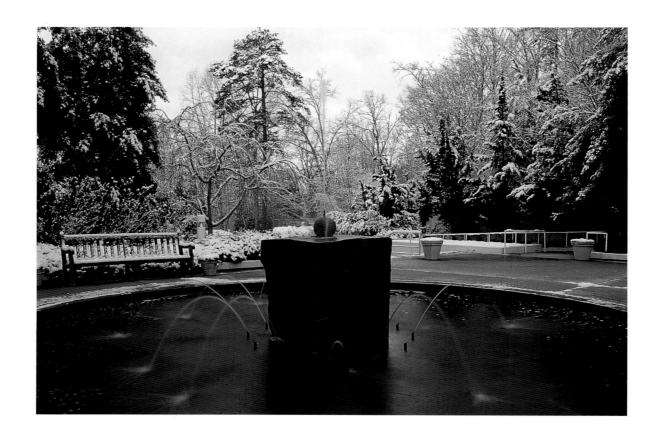

ABOVE

The Visitor Center fountain in the snow

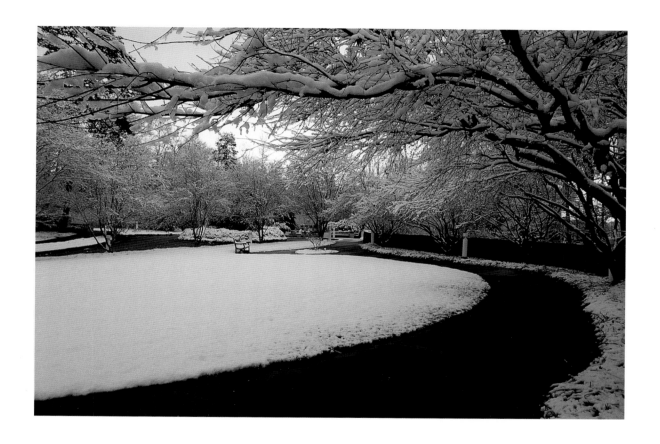

Snow covering a row of Japanese maples (*Acer palmatum*) along the path to the Visitor Center

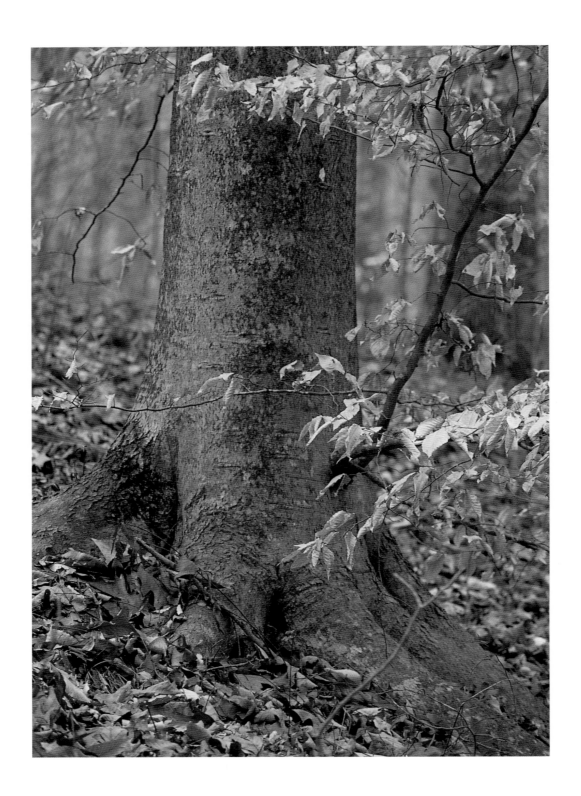

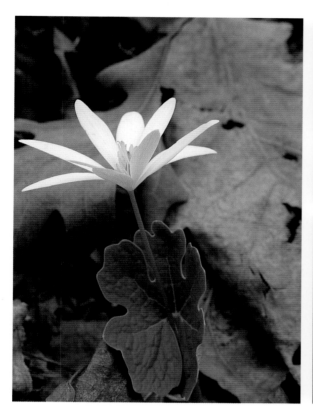

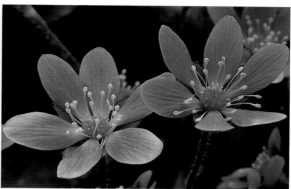

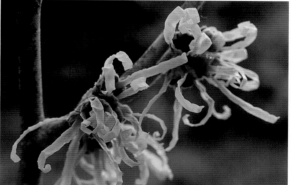

FACING PAGE

The leaves of a young American beech (*Fagus grandifolia*) stay
on the tree during winter

ABOVE, CLOCKWISE FROM TOP RIGHT

Hepatica (*Hepatica americana*) is first to bloom in January on the Orange Trail

Japanese witch hazel (*Hamamelis japonica* 'Sulphurea')

Bloodroot (*Sanguinaria canadensis*) blooms among fallen oak leaves
in January on the Orange Trail

OVERLEAF

Overview of the International Garden in the snow

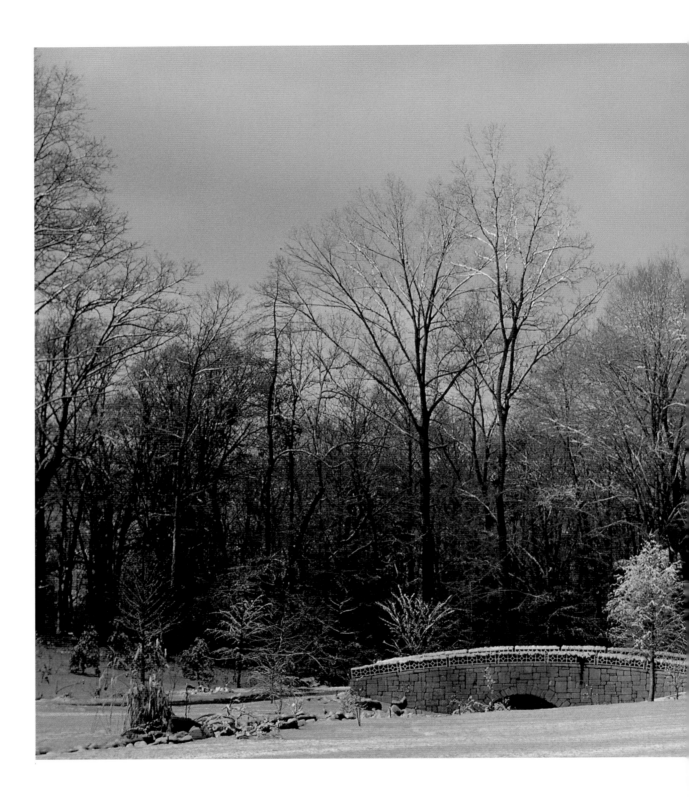

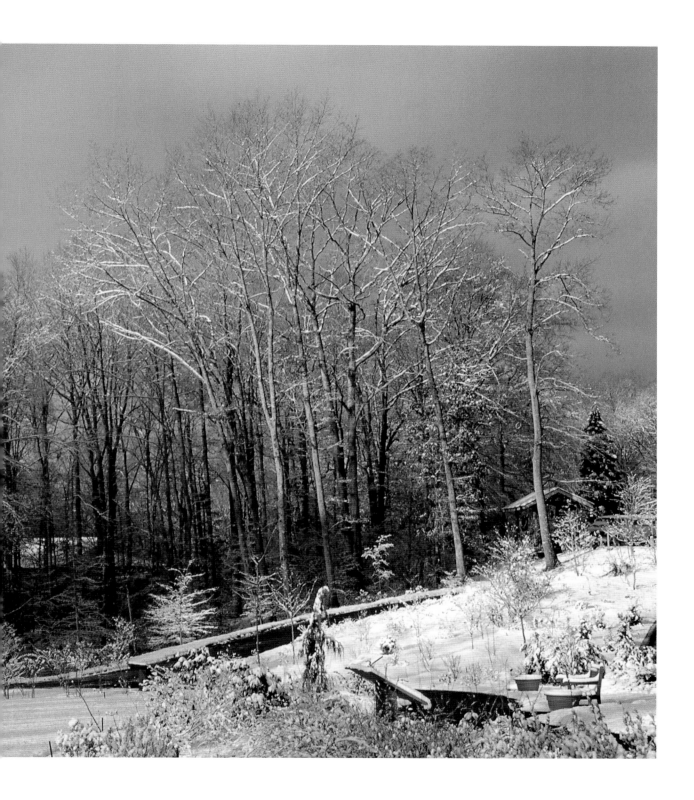

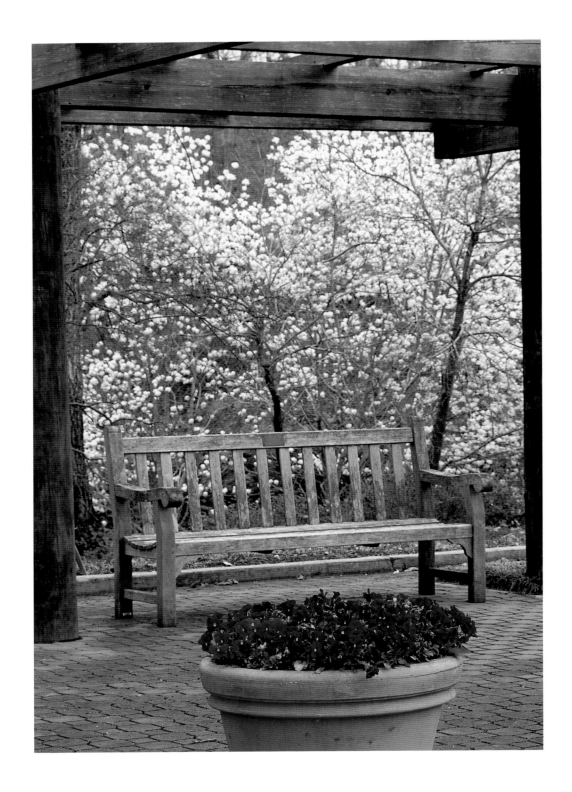

FACING PAGE

Pansies (*Viola* x *wittrockiana*) in pots and lily tree (*Magnolia denudata*) viewed through an arbor

ABOVE, LEFT TO RIGHT

Saucer magnolia (*Magnolia* x *soulangiana* 'Alexandrina') blooming in February

Spring cannot be far away when bluebells (*Mertensia virginica*) bloom in the Dunson Native Flora Garden

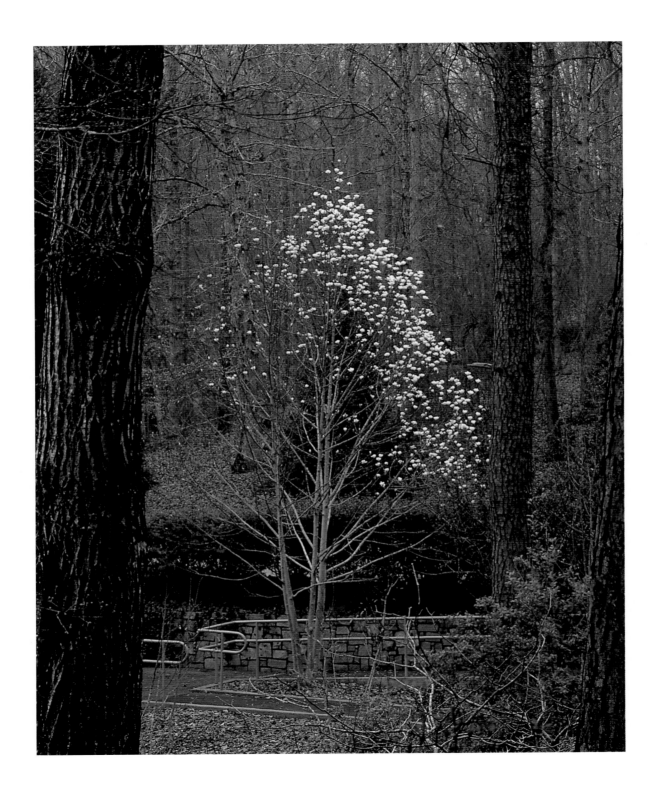

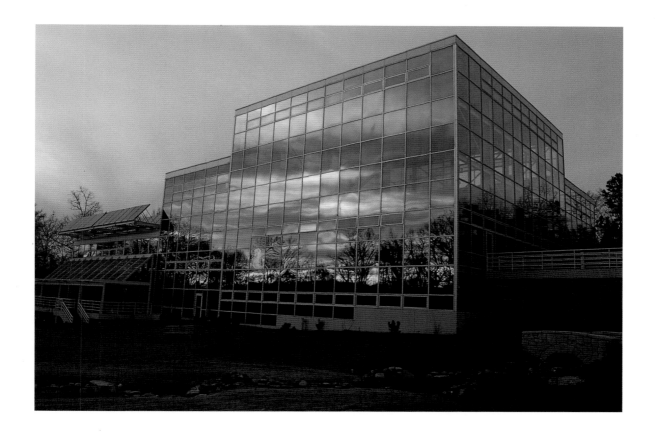

FACING PAGE

Cucumber tree (*Magnolia acuminata*) in the Shade Garden

ABOVE

Conservatory at sunset from the International Garden

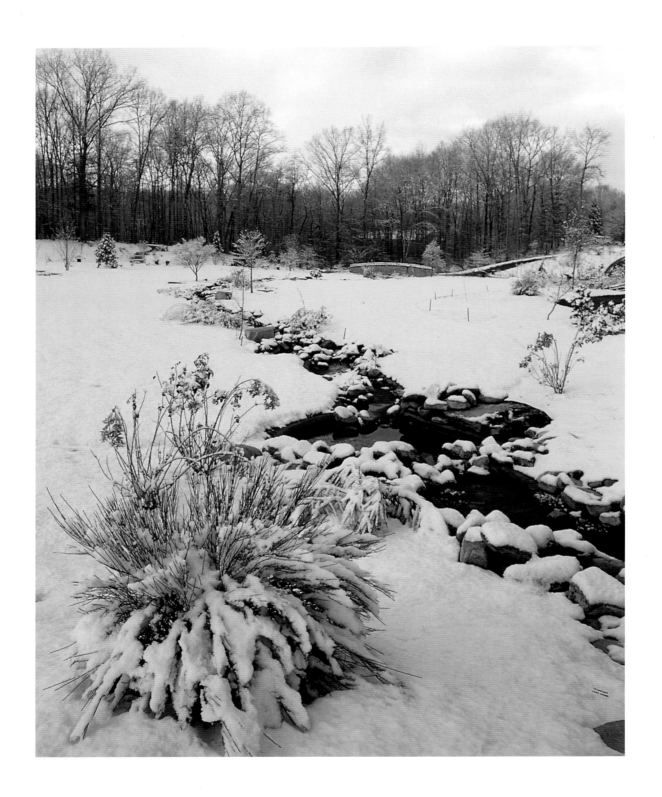

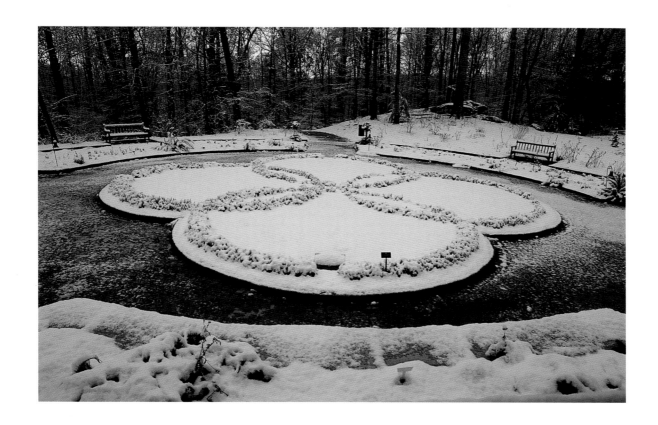

FACING PAGE

International Garden stream in the snow

ABOVE

The Physic Garden's knot garden in the snow

FOLLOWING PAGES

Agave (*Agave*) in the snow in the Herb Garden
Camellia (*Camellia japonica* 'Empress')

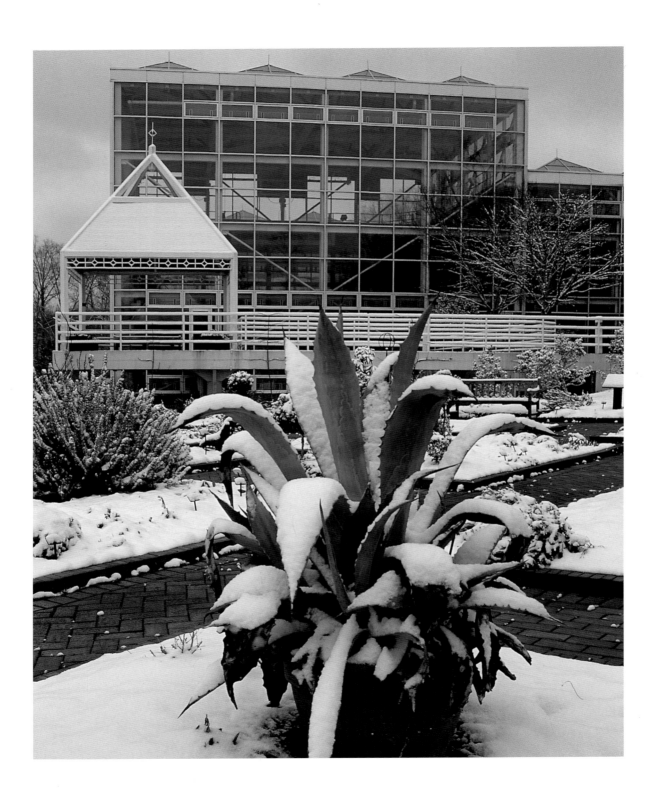

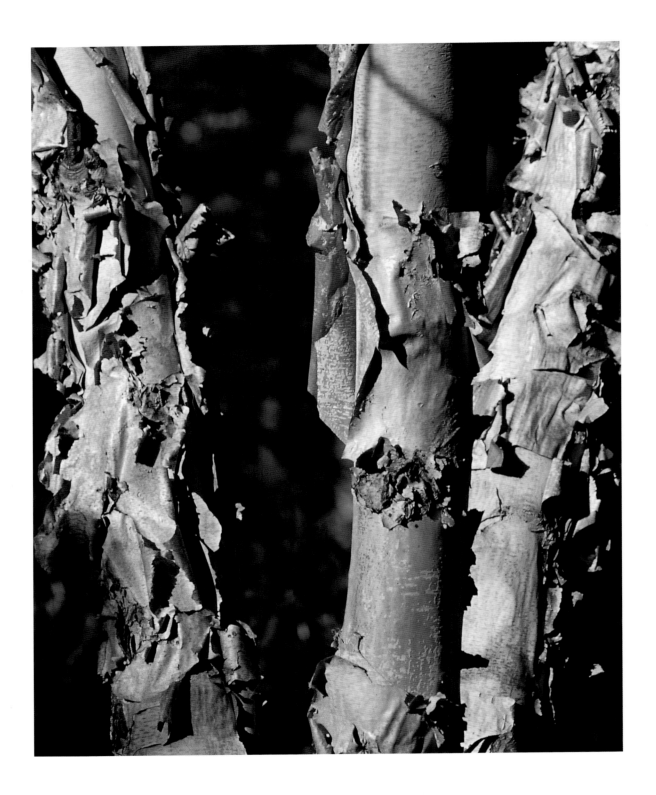

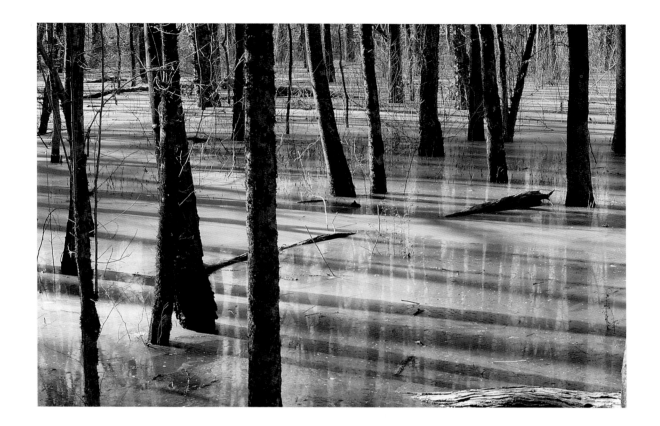

FACING PAGE

The fascinating bark curls of the river birch (*Betula nigra*)

ABOVE

Beaver pond on the Orange Trail after heavy winter rains

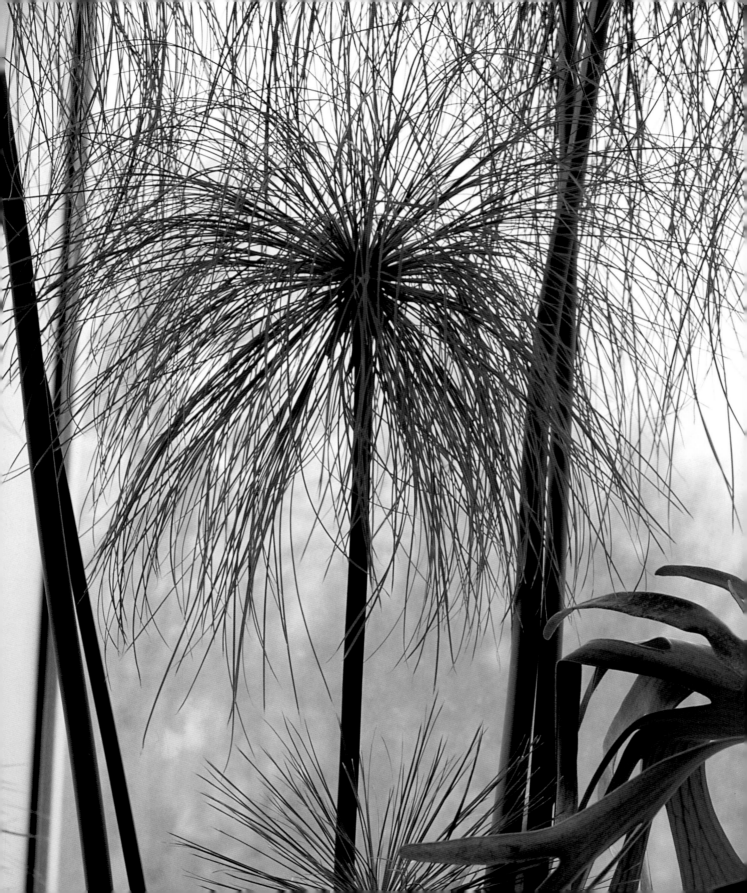

*Under Glass*

In the conservatory's controlled climate, seasonal changes are less noticeable. The even temperature and high humidity simulate conditions in the tropics and subtropics, and plant species from those regions tend to do as they would at home, with bloom times spread throughout the year. It is always an adventure to stroll down the sloping walkway from the upper to the lower level to see what is in flower.

On the lower level, the permanent trees and shrubs are tropical and subtropical species that are used for food, beverages, fibers, medicines, or other products. A papaya raises its panicles of waxy white flowers to the upper level. Some weeks later, clusters of green fruit appear, and later still, ripe orange papayas.  The star fruit (carambola) begins as clusters of tiny pink star-shaped flowers, and the cacao tree has beautiful little blossoms along its leafless trunk and larger limbs. Papyrus, used to make paper in ancient Egypt, has pompoms of grassy leaves on long reedy stalks.

Filling in among the permanent plantings are ornamental plants with attractive or interesting flowers and foliage. Heliconias, holiday cactuses, or angel trumpets may be in bloom. Flowering orchids from the Garden's collection

are rotated into the conservatory from the greenhouses. Devil's tongue has a large spathe with a protruding tonguelike spadix and an unpleasant odor that may attract flies as pollinators. Early-morning visitors to the conservatory may see the large white flowers of the night-blooming cactus, which open for a single night and close with the arrival of daylight.

On the upper level of the conservatory, potted plants add color to beds of foliage plants. Cinerarias, amaryllis, pentas, and kalanchoes, brought in from the greenhouses when in bloom, often serve as bright 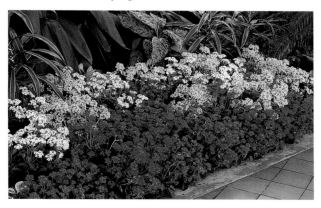 accents. When it flowers, a gardenia perfumes the whole building from a container near the rear door.

Two special events bring seasonal displays to the Visitor Center. For the Gardens of the World Ball, a major fund-raising event held in May, plants and decorations from the country chosen as that year's theme are used. And for the holiday season, poinsettias from the greenhouse are used with decorations made from natural materials from the Garden.

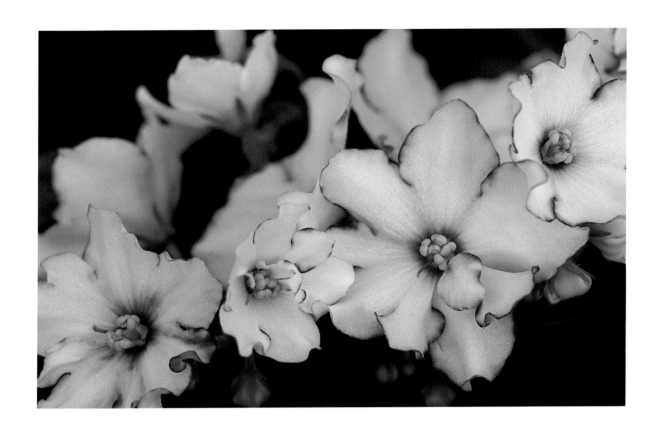

ABOVE
African violets (*Saintpaulia*)

FACING PAGE
Night blooming cactus (*Hylocereus*),
which has blooms that open for a single night and close up with daylight

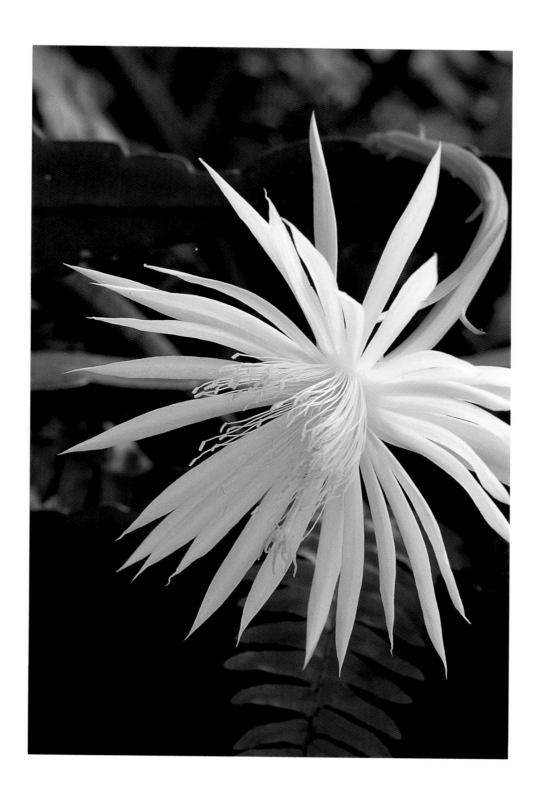

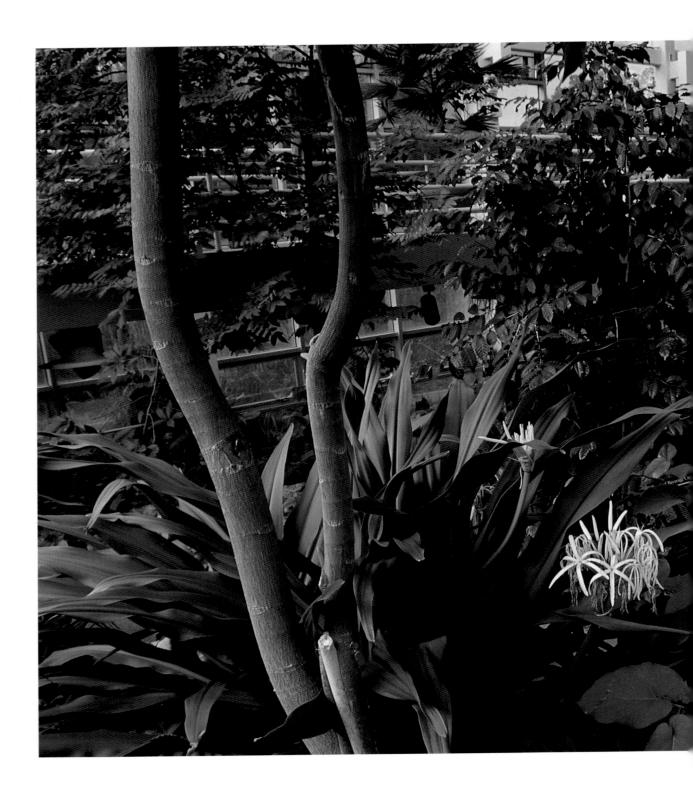

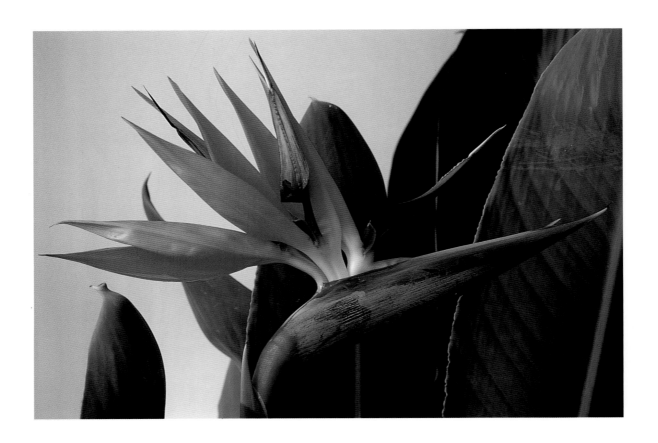

PRECEDING PAGE
Spider lily (*Crinum giganteum*) and tropical bleeding heart
(*Clerodendrum thomsoniae*)

ABOVE
Bird of paradise (*Strelitzia reginae*)

ABOVE
Carrion flower (*Stapelia gigantea*)

OVERLEAF
Poinsettia (*Euphorbia pulcherrima*) display

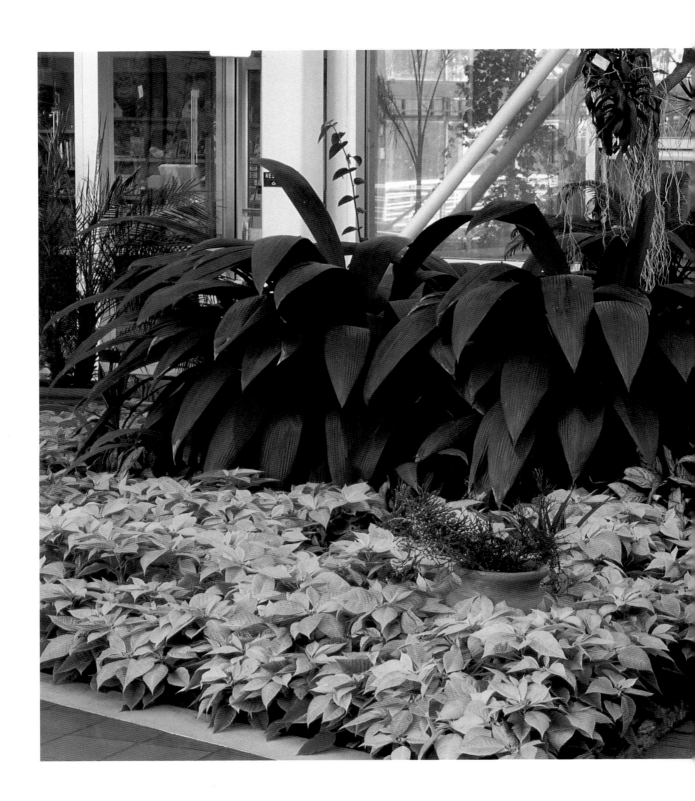

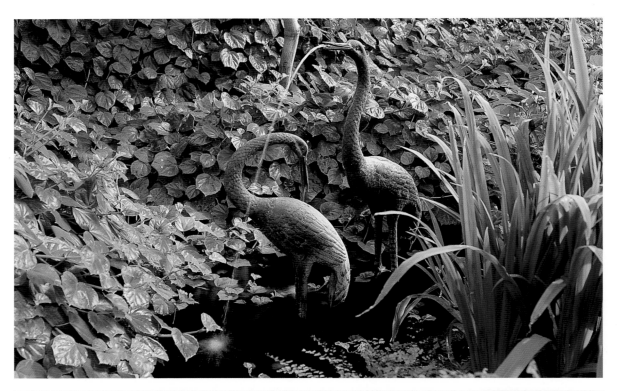

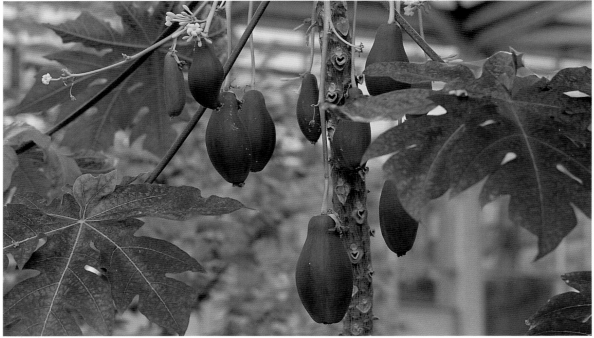

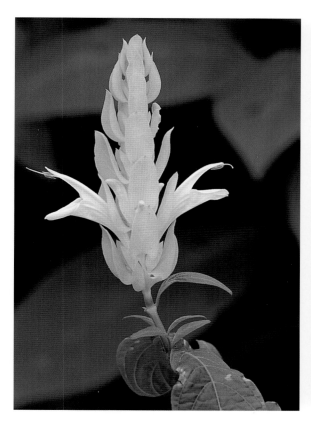
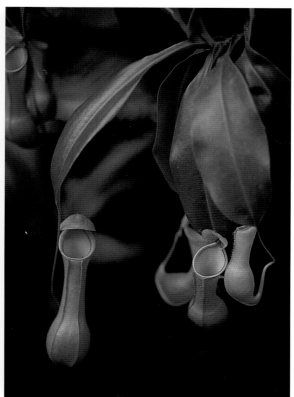

FACING PAGE, ABOVE AND BELOW
The Crane Fountain
Papaya (*Carica papaya*)

ABOVE, LEFT TO RIGHT
Lollipop plant (*Pachystachys lutea*)
Tropical pitcher plant (*Nepenthes alata*)

FOLLOWING PAGES
Amaryllis (*Hippeastrum* 'Red Lion')
Amaryllis (*Hippeastrum* 'Red Lion') close-up

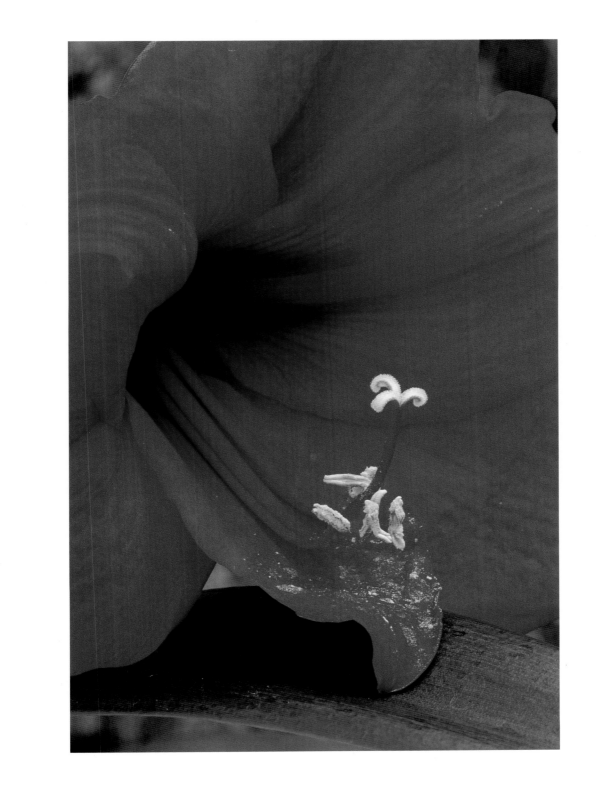

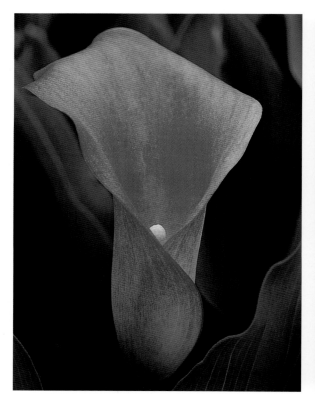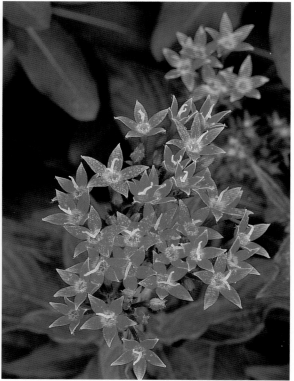

ABOVE, LEFT TO RIGHT

Calla rose lily (*Zantedeschia* 'Rose Gem')

Star cluster (*Pentas lanceolata*)

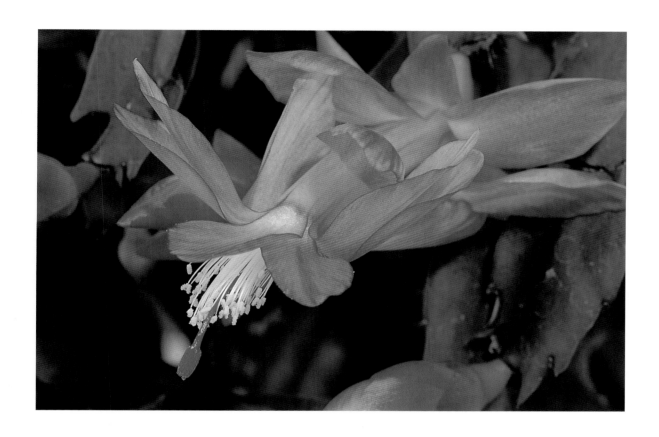

Holiday cactus (*Schlumbergera*)

# BLOOM LIST

THIS IS A PARTIAL LIST of selected blooming woody and herbaceous perennial plants that can be found at the State Botanical Garden. In many cases you will find multiple species of any given genus and almost always multiple cultivars of these species. Plants are continuously being added and sometimes removed, so this list is not static. Annuals and tropical conservatory species are not included in this list.

Keep in mind that flowering times vary somewhat from year to year. Of course, flowers are not the only thing to see in the Garden. Very often bark, berries, forms, and foliage colors can be every bit as interesting. For the observant visitor, there is much of interest to be found at the Garden throughout the entire year.

### JANUARY

*Camellia japonica* and *C. sasanqua* (Camellia, Sasanqua)
*Chaenomeles japonica* (Flowering quince)
*Crocus* species and hybrids (Crocus)
*Daphne odora* (Winter daphne)
*Galanthus nivalis* (Snowdrop)
*Hamamelis* species and hybrids (Witch hazel)
*Helleborus orientalis* (Lenten rose)
*Hepatica americana* (Hepatica)
*Jasminium nudiflorum* (Winter jasmine)
*Magnolia* species and hybrids (Magnolia)
*Mahonia japonica* 'Bealei' (Leatherleaf mahonia)

### FEBRUARY

*Camellia japonica* and *C. sasanqua* (Camellia, Sasanqua)
*Chaenomeles japonica* (Flowering quince)
*Crocus* species and hybrids (Crocus)
*Daphne odora* (Winter daphne)
*Forsythia* x *intermedia* (Forsythia)
*Galanthus nivalis* (Snowdrop)
*Gelsemium sempervirens* (Carolina jasmine)
*Hamamelis* species and hybrids (Witch hazel)
*Helleborus orientalis* (Lenten rose)
*Hepatica americana* (Hepatica)
*Iris* species and hybrids (Iris)

*Jasminium nudiflorum* (Winter jasmine)

*Magnolia* species and hybrids (Magnolia)

*Mahonia japonica* 'Bealei' (Leatherleaf mahonia)

*Mertensia virginica* (Bluebells)

*Narcissus* species and hybrids (Daffodil, Narcissus, Jonquil)

*Phlox* species (Phlox)

*Sanguinaria canadensis* (Bloodroot)

*Spiraea* species and hybrids (Spiraea)

*Viola* species (Violet)

MARCH

*Aesculus* species (Buckeye)

*Camellia japonica* and *C. sasanqua* (Camellia, Sasanqua)

*Cercis canadensis* (Eastern redbud)

*Chaenomeles japonica* (Flowering quince)

*Chrysogonum virginianum* (Green-and-gold)

*Crocus* species and hybrids (Crocus)

*Daphne odora* (Winter daphne)

*Dicentra* species (Bleeding heart)

*Forsythia* x *intermedia* (Forsythia)

*Fothergilla gardenii* (Dwarf fothergilla)

*Galanthus nivalis* (Snowdrop)

*Gelsemium sempervirens* (Carolina jasmine)

*Hamamelis* species and hybrids (Witch hazel)

*Helleborus orientalis* (Lenten rose)

*Iris* species and hybrids (Iris)

*Jasminium nudiflorum* (Winter jasmine)

*Lonicera sempervirens* (Coral honeysuckle)

*Loropetalum chinensis* (Loropetalum)

*Magnolia* species and hybrids (Magnolia)

*Malus* species (Crabapple)

*Mertensia virginica* (Bluebells)

*Narcissus* species and hybrids (Daffodil, Narcissus, Jonquil)

*Phlox* species (Phlox)

*Pieris japonica* (Japanese pieris)

*Prunus* species (Flowering cherry)

*Pyrus calleryana* (Flowering pear)

*Rhododendron* species and hybrids (Rhododendron, Azalea)

*Sanguinaria canadensis* (Bloodroot)

*Spiraea* species and hybrids (Spiraea)

*Trillium* species (Trillium)

*Tulipa* species and hybrids (Tulip)

*Viburnum* species and hybrids (Viburnum)

*Viola* species (Violet)

APRIL

*Aesculus* species (Buckeye)

*Ajuga reptans* (Bugleweed)

*Astilbe* species and hybrids (False spiraea)

*Calycanthus floridus* (Sweetshrub)

*Camellia japonica* and *C. sasanqua* (Camellia, Sasanqua)

*Cercis canadensis* (Eastern redbud)

*Chionanthus virginicus* (Fringe tree)

*Chrysogonum virginianum* (Green-and-gold)

*Clematis* species and hybrids (Clematis)

*Cornus florida* and *C. kousa* (Dogwood, Kousa dogwood)

*Deutzia gracilis* (Slender deutzia)

*Dianthus* species (Dianthus)

*Dicentra* species (Bleeding heart)
*Fothergilla gardenii* (Dwarf fothergilla)
*Gelsemium sempervirens* (Carolina jasmine)
*Halesia carolina* (Carolina silverbell)
*Iris* species and hybrids (Iris)
*Itea virginica* (Virginia sweetspire)
*Kolkwitzia amabilis* (Beautybush)
*Lonicera sempervirens* (Coral honeysuckle)
*Loropetalum chinensis* (Loropetalum)
*Malus* species (Crabapple)
*Michelia figo* (Banana shrub)
*Narcissus* species and hybrids (Daffodil,
    Narcissus, Jonquil)
*Phlox* species (Phlox)
*Pieris japonica* (Japanese pieris)
*Prunus* species (Flowering cherry)
*Rhododendron* species and hybrids
    (Rhododendron, Azalea)
*Rosa* species and hybrids (Rose)
*Sarracenia* species (Pitcher plant)
*Spigelia marilandica* (Indian pink)
*Spiraea* species and hybrids (Spiraea)
*Tradescantia virginiana* (Spiderwort)
*Trillium* species (Trillium)
*Tulipa* species and hybrids (Tulip)
*Viburnum* species and hybrids (Viburnum)
*Viola* species (Violet)
*Wisteria* species (Wisteria)

## MAY

*Achillea* species (Yarrow)
*Ajuga reptans* (Bugleweed)

*Astilbe* species and hybrids (False spiraea)
*Buddleia davidii* (Butterfly bush)
*Calycanthus floridus* (Sweetshrub)
*Chrysogonum virginianum* (Green-and-gold)
*Clematis* species and hybrids (Clematis)
*Cornus florida* and *C. kousa* (Dogwood, Kousa
    dogwood)
*Dianthus* species (Dianthus)
*Dicentra* species (Bleeding heart)
*Echinacea purpurea* (Purple coneflower)
*Gardenia augusta* (Cape jasmine)
*Hemerocallis* hybrids (Daylily)
*Hosta* species (Hosta)
*Hypericum* species (St. Johns wort)
*Iris* species and hybrids (Iris)
*Itea virginica* (Virginia sweetspire)
*Kalmia latifolia* (Mountain laurel)
*Kniphofia uvaria* (Red-hot poker)
*Kolkwitzia amabilis* (Beautybush)
*Liatris* species (Blazing star)
*Magnolia* species and hybrids (Magnolia)
*Michelia figo* (Banana shrub)
*Phlox* species (Phlox)
*Rhododendron* species and hybrids
    (Rhododendron, Azalea)
*Rosa* species and hybrids (Rose)
*Sarracenia* species (Pitcher plant)
*Silene polypetala* (Fringed campion)
*Spigelia marilandica* (Indian pink)
*Tradescantia virginiana* (Spiderwort)
*Verbena* species and hybrids (Verbena)
*Viburnum* species and hybrids (Viburnum)
*Wisteria* species (Wisteria)

## JUNE

*Achillea* species (Yarrow)

*Asclepias tuberosa* (Butterfly weed)

*Astilbe* species and hybrids (False spiraea)

*Buddleia davidii* (Butterfly bush)

*Campsis radicans* (Trumpet creeper)

*Canna* x *generalis* (Canna)

*Clematis* species and hybrids (Clematis)

*Coreopsis* species (Tickseed)

*Cotinus coggygria* (Smokebush)

*Dianthus* species (Dianthus)

*Echinacea purpurea* (Purple coneflower)

*Gardenia augusta* (Cape jasmine)

*Gordonia lasianthus* (Loblolly bay)

*Helianthus* species (Sunflower)

*Hemerocallis* hybrids (Daylily)

*Hibiscus* species (Hibiscus)

*Hosta* species (Hosta)

*Hydrangea* species (Hydrangea)

*Hypericum* species (St. John's wort)

*Kalmia latifolia* (Mountain laurel)

*Kniphofia uvaria* (Red-hot poker)

*Lagerstroemia* species and hybrids (Crape myrtle)

*Liatris* species (Blazing star)

*Lilium* species and hybrids (Lily)

*Lysimachia clethroides* (Loosestrife)

*Magnolia* species and hybrids (Magnolia)

*Monarda didyma* (Bee balm)

*Phlox* species (Phlox)

*Rhododendron* species and hybrids
    (Rhododendron, Azalea)

*Rosa* species and hybrids (Rose)

*Rudbeckia* species (Black-eyed Susan)

*Salvia* species (Sage)

*Tradescantia virginiana* (Spiderwort)

*Verbena* species and hybrids (Verbena)

*Vitex agnus-castus* (Chaste tree)

*Wisteria* species (Wisteria)

## JULY

*Achillea* species (Yarrow)

*Aesculus* species (Buckeye)

*Asclepias tuberosa* (Butterfly weed)

*Belamcanda chinensis* (Blackberry lily)

*Buddleia davidii* (Butterfly bush)

*Campsis radicans* (Trumpet creeper)

*Canna* x *generalis* (Canna)

*Clematis* species and hybrids (Clematis)

*Coreopsis* species (Tickseed)

*Cotinus coggygria* (Smokebush)

*Dahlia* hybrids (Dahlia)

*Dianthus* species (Dianthus)

*Echinacea purpurea* (Purple coneflower)

*Gardenia augusta* (Cape jasmine)

*Gordonia lasianthus* (Loblolly bay)

*Helianthus* species (Sunflower)

*Hemerocallis* hybrids (Daylily)

*Hibiscus* species (Hibiscus)

*Hosta* species (Hosta)

*Hydrangea* species (Hydrangea)

*Hypericum* species (St. John's wort)

*Lagerstroemia* species and hybrids (Crape myrtle)

*Liatris* species (Blazing star)

*Lilium* species and hybrids (Lily)

*Lobelia cardinalis* (Cardinal flower)
*Lysimachia clethroides* (Loosestrife)
*Magnolia* species and hybrids (Magnolia)
*Monarda didyma* (Bee balm)
*Rhododendron* species and hybrids
   (Rhododendron, Azalea)
*Rudbeckia* species (Black-eyed Susan)
*Salvia* species (Sage)
*Verbena* species and hybrids (Verbena)
*Vitex agnus-castus* (Chaste tree)

## AUGUST

*Buddleia davidii* (Butterfly bush)
*Campsis radicans* (Trumpet creeper)
*Canna* x *generalis* (Canna)
*Clematis* species and hybrids (Clematis)
*Clethra alnifolia* (Summersweet clethra)
*Coreopsis* species (Tickseed)
*Dahlia* hybrids (Dahlia)
*Dianthus* species (Dianthus)
*Gordonia lasianthus* (Loblolly bay)
*Helianthus* species (Sunflower)
*Hibiscus* species (Hibiscus)
*Hosta* species (Hosta)
*Hydrangea* species (Hydrangea)
*Hypericum* species (St. John's wort)
*Kosteletzkya virginica* (Salt marsh mallow)
*Lagerstroemia* species and hybrids
   (Crape myrtle)
*Lilium* species and hybrids (Lily)
*Liriope muscari* (Lilyturf)
*Lobelia cardinalis* (Cardinal flower)

*Lysimachia clethroides* (Loosestrife)
*Monarda didyma* (Bee balm)
*Rudbeckia* species (Black-eyed Susan)
*Salvia* species (Sage)
*Sedum spectabile* (Autumn sedum)
*Verbena* species and hybrids (Verbena)

## SEPTEMBER

*Aster* species and hybrids (Aster)
*Buddleia davidii* (Butterfly bush)
*Canna* x *generalis* (Canna)
*Chrysanthemum* x *morifolium* (Chrysanthemum)
*Clematis* species and hybrids (Clematis)
*Clethra alnifolia* (Summersweet clethra)
*Coreopsis* species (Tickseed)
*Dahlia* hybrids (Dahlia)
*Dianthus* species (Dianthus)
*Eupatorium coelestinum* (Hardy ageratum)
*Helianthus* species (Sunflower)
*Hibiscus* species (Hibiscus)
*Hosta* species (Hosta)
*Hydrangea* species (Hydrangea)
*Hypericum* species (St. John's wort)
*Koelreuteria bipinnata* (Golden-rain tree)
*Lilium* species and hybrids (Lily)
*Liriope muscari* (Lilyturf)
*Lobelia cardinalis* (Cardinal flower)
*Lycoris* species (Red spider lily)
*Salvia* species (Sage)
*Sedum spectabile* (Autumn sedum)
*Tricyrtis hirta* (Toad lily)
*Verbena* species and hybrids (Verbena)

*Aster* species and hybrids (Aster)

*Buddleia davidii* (Butterfly bush)

*Chrysanthemum* x *morifolium* (Chrysanthemum)

*Crocus* species and hybrids (Crocus)

*Dahlia* hybrids (Dahlia)

*Dianthus* species (Dianthus)

*Eupatorium coelestinum* (Hardy ageratum)

*Osmanthus heterophyllus* (Holly osmanthus)

*Rosa* species and hybrids (Rose)

*Salvia* species (Sage)

*Sedum spectabile* (Autumn sedum)

*Tricyrtis hirta* (Toad lily)

## NOVEMBER

*Camellia japonica* and *C. sasanqua* (Camellia, Sasanqua)

*Hamamelis* species and hybrids (Witch hazel)

*Osmanthus heterophyllus* (Holly osmanthus)

*Rosa* species and hybrids (Rose)

*Salvia* species (Sage)

## DECEMBER

*Camellia japonica* and *C. sasanqua* (Camellia, Sasanqua)

*Hamamelis* species and hybrids (Witch hazel)